IMAGES
of America

ANDERSON

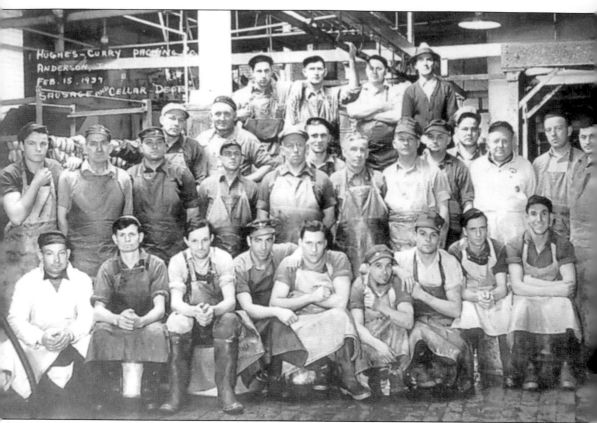

Employees of Hughes Curry epitomize the working middle class in this 1937 photograph. Hughes Curry, located on West Eighth Street, later became Emge Packing Plant. The meatpacking plant was one of many Anderson factories that served as a cornerstone of the city's economic and job growth during the mid-1900s. (Courtesy of the *Anderson Herald Bulletin*.)

ON THE COVER: Hundreds of Delco Remy employees attend a flag-raising ceremony before the workday begins. This photograph was taken in 1917, when the United States was involved in World War I. (Courtesy of the Anderson Public Library.)

IMAGES
of America

ANDERSON

David Humphrey

ARCADIA
PUBLISHING

Copyright © 2014 by David Humphrey
ISBN 978-1-4671-1174-4

Published by Arcadia Publishing
Charleston, South Carolina

Printed in the United States of America

Library of Congress Control Number: 2013950697

For all general information, please contact Arcadia Publishing:
Telephone 843-853-2070
Fax 843-853-0044
E-mail sales@arcadiapublishing.com
For customer service and orders:
Toll-Free 1-888-313-2665

Visit us on the Internet at www.arcadiapublishing.com

This book is for my father, who passed his love for history on to me.

CONTENTS

Acknowledgments 6

Introduction 7

1. Downtown Anderson 9

2. People 35

3. Sports and Entertainment 57

4. Around Town 85

5. Postcards, Advertisements, and Documents 105

ACKNOWLEDGMENTS

I would like to thank the following for making this book possible: Anderson Downtown Neighbors Association, *Anderson Herald Bulletin*, Anderson High School, Anderson Public Library, Community Hospital Anderson, Norm Cook family, Mike Covington, Roger Hensley, Highland High School, George Humphrey, If You Grew Up in Anderson, Stephen Jackson, Perry Knox, Madison County Historical Society, Madison Heights High School, Martha Green, Mounds State Park, Everett Muterspaugh, Mike Nuce, Sam Nunn, Beth Oljace, Paramount Theatre Centre and Ballroom, Louis Priddy, Harvey Riedel, Chuck Rossen, Saint Mary's Catholic Church, Saint Mary's School, Saint Vincent Anderson Regional Hospital, United Auto Workers Local 663, and the Urban League of Madison County.

INTRODUCTION

Anderson has been known as the "Redbud Capital of the World," a General Motors town, and host of the greatest high school basketball sectional ever held in the Hoosier state. But, no matter what label might be placed on the city, Anderson has played an integral role in helping to shape the foundation of Indiana and Madison County.

Perhaps the most important year in the history of Anderson is 1887, when natural gas was found beneath the city. The once-sleepy little town soon became a prosperous metropolis and thriving industrial center. By 1890, the natural-gas boom provided over 8,000 men with jobs and contributed an estimated $3 million to the city's economy. As the gas fields and employment continued to grow, so too did Anderson's population. In 1880, Anderson had a population of 4,000. After the turn of the 20th century, over 20,000 people called the city home.

When natural gas began to run out in 1912, the shortage resulted in the closing of several factories and an economic slowdown in the city. However, the Commercial Club, later called the chamber of commerce, persuaded several prominent businessmen to stay in Anderson and invited outside businesses to relocate here. Among them were Frank and Perry Remy, two brothers who opened a home-wiring business in Anderson in 1886. The family-owned business was the forerunner to Delco Remy, which became a division of General Motors in 1918. In 1926, Guide Lamp began operations in Anderson and was part of the Delco Remy Division. For the next 70 years, Guide Lamp and Delco Remy employed thousands of Anderson-area residents and served as the backbone to the city's economy.

After a long week working on the assembly line, teaching in the classroom, or driving a city bus or taxicab, residents headed to downtown Anderson on the weekend. From the 1940s to the 1970s, Meridian Street was abuzz with hundreds, if not thousands, of people, walking heel to heel on the crowded city sidewalks. The Paramount, State, Riviera, and Times movie theaters showed the latest Hollywood releases, while clothing and record stores offered the hottest trends in fashion and music. There was an array of restaurants, five-and-dime stores, and magazine and newspaper stands.

The Anderson basketball sectional will long be remembered as one of the most celebrated events of the year. Tickets to the event, held every February in the Anderson High School Wigwam, were as hard to obtain then as a Bruce Springsteen concert ticket is today. Fans with seats in Section YY withstood the long trek up the steps to the infamous "nose-bleed section" to root for their favorite team or player. Picking what team might win the sectional was as unlikely as predicting the amount of snowfall that would occur during the tournament.

Granted, there is more to Anderson's history than thriving businesses, entertainment, and sports. It also includes the laborers who built the city with their two hands, the educators who selflessly taught day in and day out, and the families who stood together during hard and difficult times.

The photographs in this book, from the late 1800s to the early 1980s, are as diverse as the people of Anderson. Behind every picture is a story, no matter who the storyteller might be. Though memories often fade, photographs remain clear with the passage of time.

One

DOWNTOWN ANDERSON

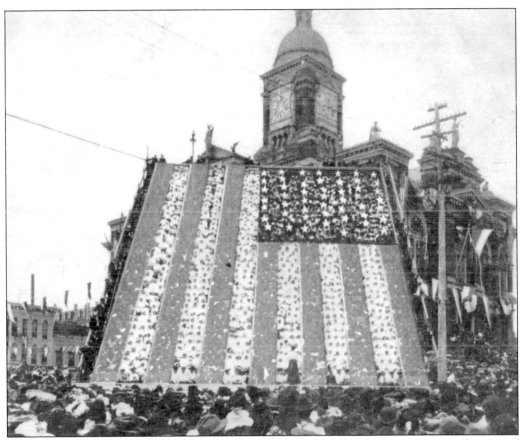

The Living Flag, composed of 2,000 schoolchildren, was exhibited during the Grand Army of the Republic convention held in Anderson on May 13, 1903. The children, wearing red, white, and blue clothing, filled a scaffold constructed on Courthouse Square that reached to the top of the Madison County Courthouse. Thousands of people attended the event, where they witnessed aged veterans of the Civil War parade past the Living Flag and through downtown. The Grand Army of the Republic was an organization consisting of veterans from the Union army. (Courtesy of the Anderson Public Library.)

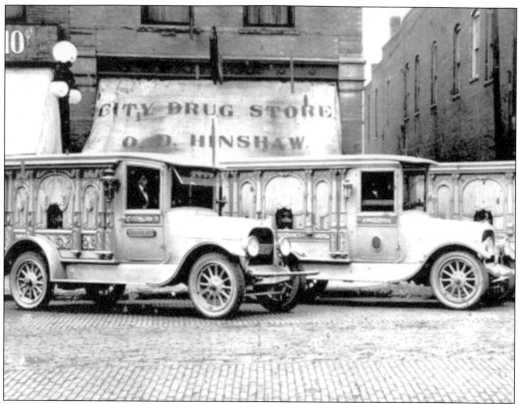

Delivery trucks park on the street outside O.D. Hinshaw's City Drug Store in downtown Anderson. (Photograph by Norm Cook; courtesy of the Norm Cook family.)

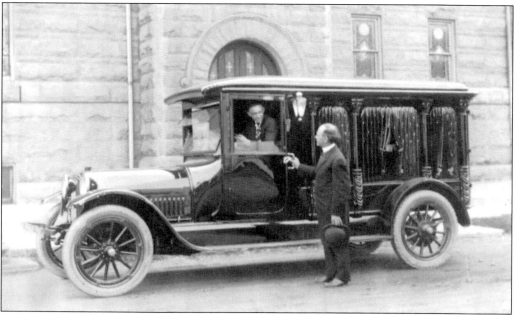

A hearse sits outside of a church while the funeral parlor owner talks with the driver. (Courtesy of the Anderson Public Library.)

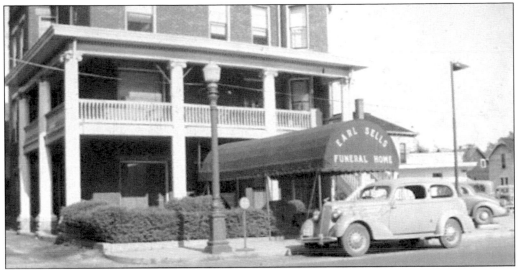

Earl Sells Funeral Home, pictured here in the 1940s, was located at 1324 Main Street. (Courtesy of Anderson Downtown Neighbors Association.)

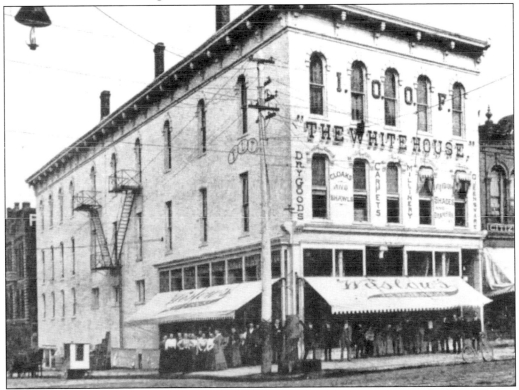

The White House was at the corner of Ninth and Meridian Streets. Owner Abraham Weslow made vast improvements after purchasing the property from John F. Wild of Noblesville. The four-story White House sold groceries, furnishings, linens, silks, carpets, rugs, and draperies. During the holiday season, Santa Claus greeted everyone from the fire escape. In the early days of the White House, the Odd Fellows and Red Men's Lodge held meetings in the building. (Courtesy of the Madison County Historical Society.)

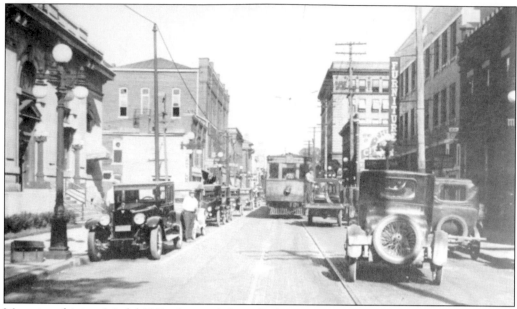

Motorists driving Model T Fords travel down Jackson Street in the 1920s. To the left is the post office. The Citizens Bank and Union Building are on the right. (Courtesy of the *Anderson Herald Bulletin*.)

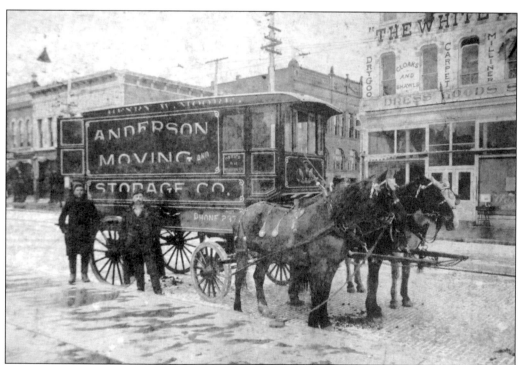

The Anderson Moving and Storage Company was owned and operated by Henry W. Moore. The company moved household furniture and hauled freight from the train depots to local merchants. In the background is the White House department store at Ninth and Meridian Streets. (Courtesy of the Anderson Downtown Neighbors Association.)

A pedestrian waits for the traffic light to change outside Haag's Drugs, at the corner of Tenth and Meridian Streets. To the left of Haag's is McCrory's, a store that was known for selling hot peanuts at the candy counter. Above Haag's Drugs on the second floor is the Personal Finance Company. (Courtesy of the Madison County Historical Society.)

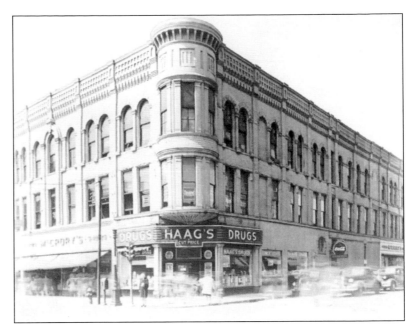

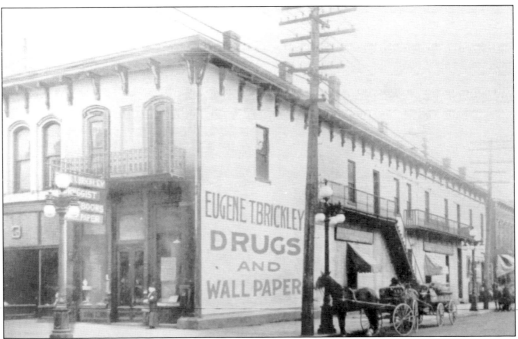

The Eugene T. Brickley Drug Store was on East Ninth Street. The corner drugstore sold books, wallpaper, perfumes, cigars, and medications. (Courtesy of the Madison County Historical Society.)

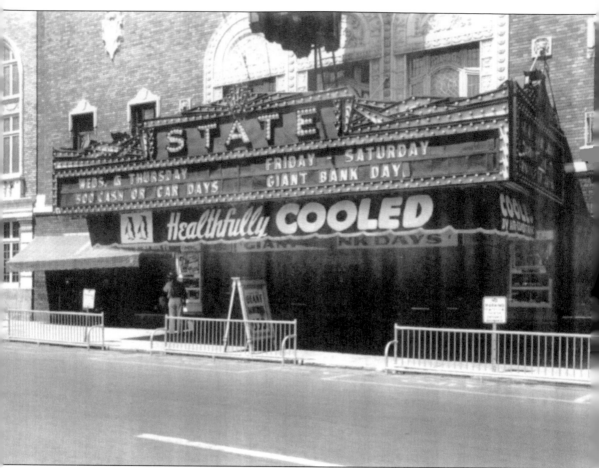

The State Theatre, located at Thirteenth and Meridian Streets, opened on May 30, 1930. Along with the Paramount Theatre, Riviera Theatre, and the Times Theatre, the State Theatre gave Meridian Street the nickname "Movie Row." Owner Harry Muller equipped the State with air-conditioning, the first theater in the city to offer this luxury to patrons. (Photograph by Norm Cook; courtesy of the Norm Cook family.)

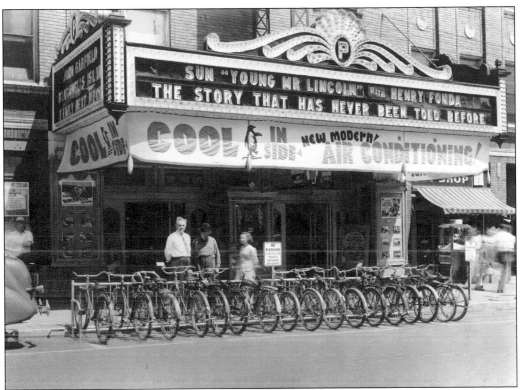

The Paramount Theatre opened on August 20, 1929, at 1124 Meridian Street. The first movie shown at the theater was *The Cocoanuts*, starring the Marx Brothers. The Paramount was designed by the famous movie theater architect John Eberson. From the 1920s through the 1980s, the Paramount showed the latest Hollywood movies, including 1939's *Young Mr. Lincoln*, starring Henry Fonda. The theater was renovated and reopened in 1995 as the Paramount Theatre Centre and Ballroom. It is listed in the National Register of Historic Places. (Courtesy of the Paramount Theatre Centre and Ballroom.)

Members of the original construction crew of the Paramount Theatre pose for a photograph inside the newly built facility. (Courtesy of the Paramount Theatre Centre and Ballroom.)

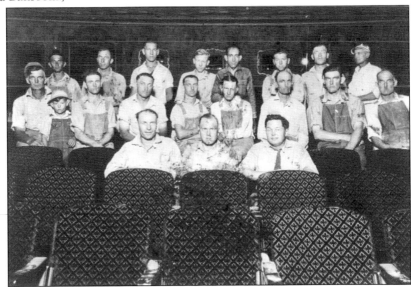

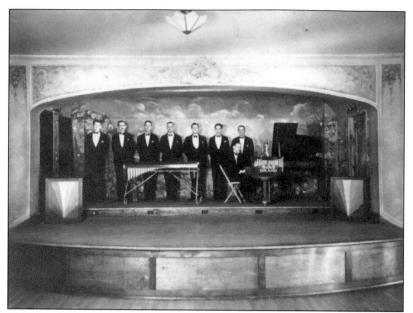

From the 1930s through the 1960s, several well-known and local musicians performed at the Paramount Theatre. After renovation of the theater in the mid-1990s, the Paramount once again hosted concerts, musicals, and dance performances. (Courtesy of the Paramount Theatre Centre and Ballroom.)

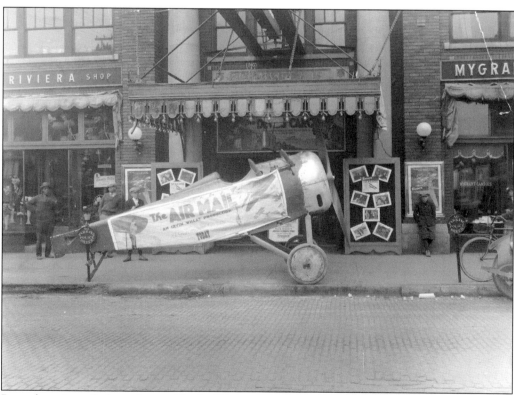

Part of an airmail plane sits outside the Riviera Theatre to promote the 1925 film *The Air Mail*, starring Warren Baxter, Billie Dove, and Douglas Fairbanks Jr. The Riviera, built in 1919, stood on the northeast corner of Twelfth and Meridian Streets. (Courtesy of the Paramount Theatre Centre and Ballroom.)

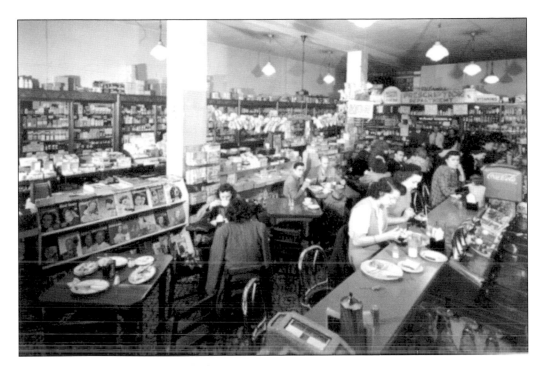

Nelson Drug Store was one of many drug stores that once operated in the downtown area. Owned by Ben Nelson, the store was located at 1134 Meridian Street. These photographs of the interior and exterior were taken in 1935. The reliable prescription drug store was cooled by Frigidair. (Both, courtesy of Madison County Historical Society.)

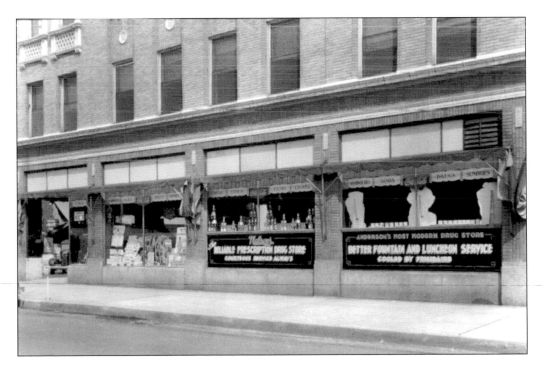

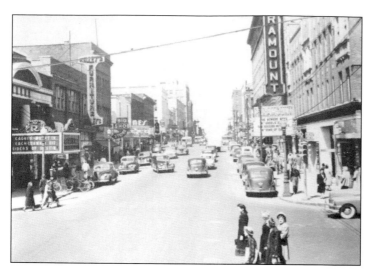

Looking north from Twelfth and Meridian Streets, three movie theaters—the Times, the Riviera, and the Paramount—are visible. One block south on Meridian Street stood the State Theatre. Showing at the Riviera Theatre is *Each Dawn I Die*, starring James Cagney and George Raft. The gangster movie was released in 1939. (Photograph by Norm Cook; courtesy of the Norm Cook family.)

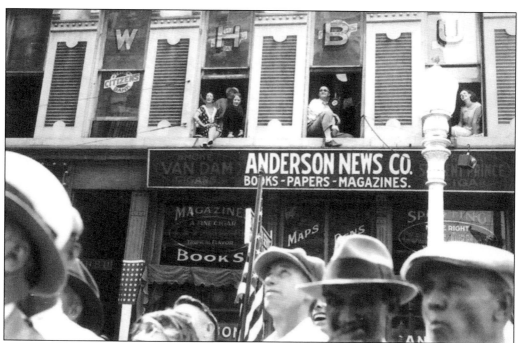

WHBU Radio and the Anderson News Company both operated within the Citizens Bank Building on Meridian Street. WHBU went on the air in 1923 and has since relocated to the town of Daleville in nearby Delaware County. The Anderson News Company moved to Twelfth and Pearl Streets. It is no longer in business. (Photograph by Norm Cook; courtesy of the Norm Cook Family.)

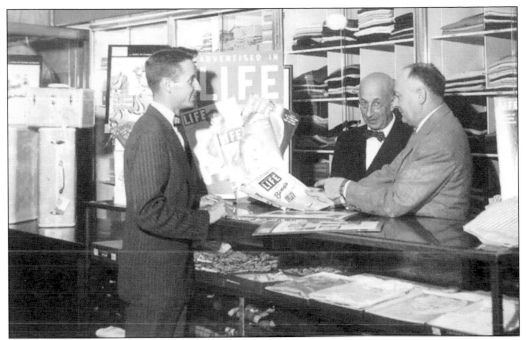

I. Monroe "Bud" Bing (second from right) and Forst Partain (right) assist a customer at Bing's Men Store, located downtown on Meridian Street. Bing was co-owner of the store, which carried top-of-the-line men's clothing. (Courtesy of the *Anderson Herald Bulletin*.)

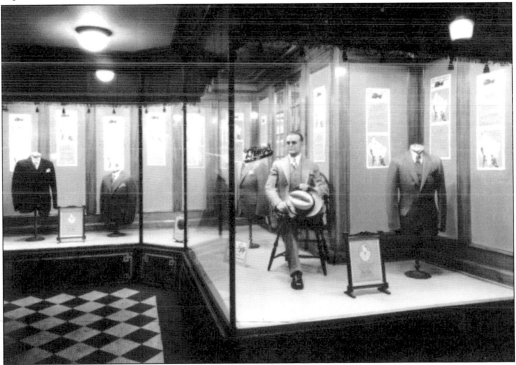

This storefront window at Bing's Men Store features a mannequin wearing one of the top fashionable suits of the day. (Courtesy of Madison County Historical Society.)

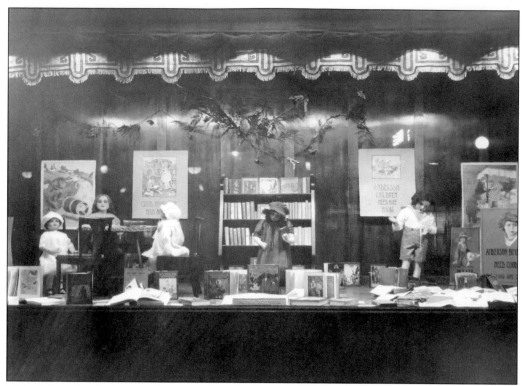

Colorful and artistic storefront window displays were a common sight during the heyday of downtown Anderson. The Fair Department Store joined with the Anderson Public Library to help promote reading to Anderson schoolchildren. (Courtesy of the Anderson Public Library.)

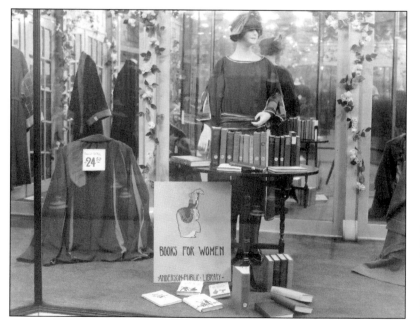

Gates Department Store touts "Books for Women" in this 1922 window display. (Courtesy of the Anderson Public Library.)

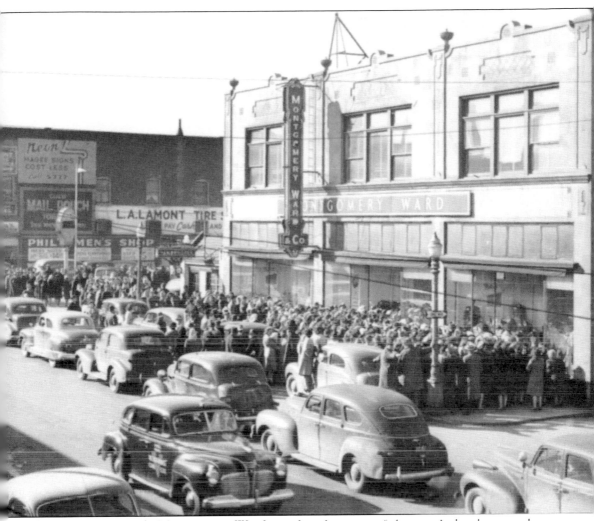

Shoppers wait outside Montgomery Ward to take advantage of the store's doorbuster sale. Montgomery Ward moved from 1325 Meridian Street to the Mounds Mall in the mid-1960s. Joe's Record Shop took over the vacated Meridian Street location. (Photograph by Norm Cook; courtesy of the Norm Cook family.)

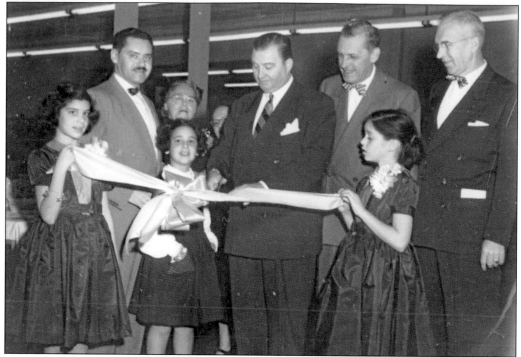

Anderson mayor Harry R. Baldwin (center) cuts the ribbon during the 1941 grand opening of Star China Company. Located on the corner of Ninth and Main Streets, Star China was owned and operated by Morris and Celia Rossen of Anderson. The establishment sold fine china, kitchenware, bridal gifts, and cooking utensils. In 2004, Morris and Celia's son Chuck closed Star China Company to concentrate on Star Photo. (Courtesy of Chuck Rossen.)

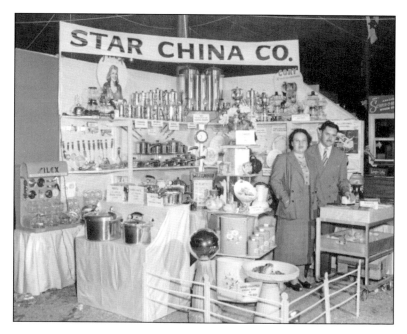

Celia and Morris Rossen are seen here at the Home Show, held every spring at the Anderson High School Wigwam. The Home Show was a major event in which entrepreneurs set up booths to promote their Anderson-area businesses. (Courtesy of Chuck Rossen.)

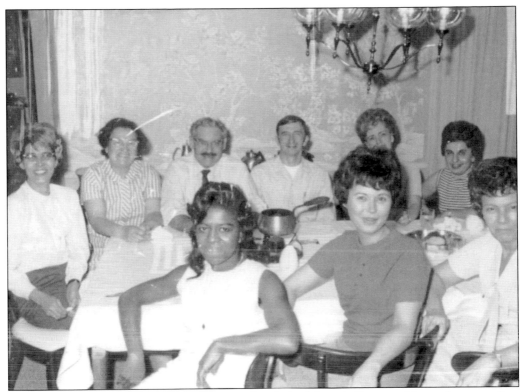

Celia and Morris Rossen (second row, second and third from left) pose with employees at Star China's annual Christmas party. Morris Rossen was one of the first downtown business owners to hire black employees. (Courtesy of Chuck Rossen.)

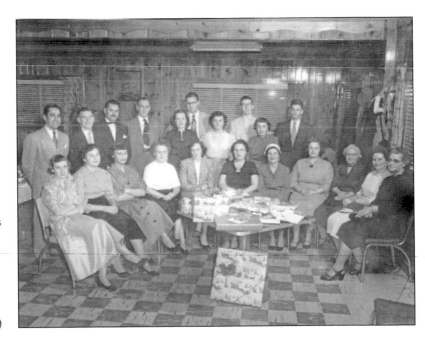

Star China employees pose for a group portrait at a 1940s Christmas party. The Rossens were known for treating employees like family. (Courtesy of Chuck Rossen.)

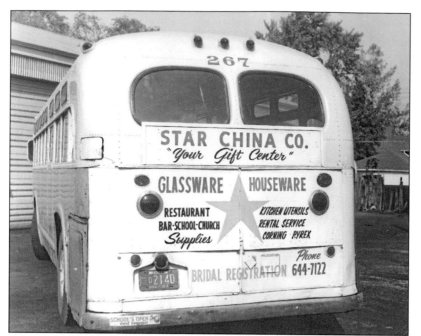

Star China Company, known as "Your Gift Center," used this bus to advertise on the streets of Anderson. This photograph was taken in 1964. (Courtesy of Chuck Rossen.)

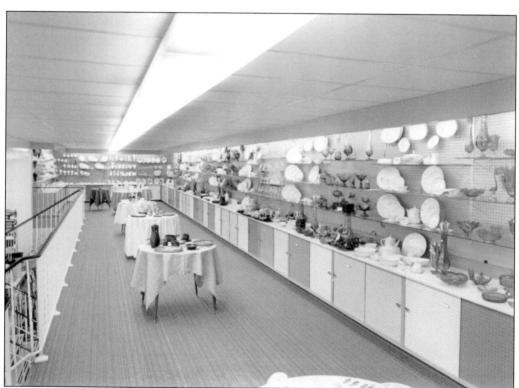

This interior photograph of Star China Company shows the second floor of the business, where fine china and glassware was displayed. (Courtesy of Chuck Rossen.)

Miller Huggins opened in 1932 in the 1100 block of Meridian Street. In 1953, the business relocated one block south to its current site at 1212 Meridian Street. The office-supplies store is one of the oldest businesses still in operation in downtown Anderson. (Courtesy of Perry Knox.)

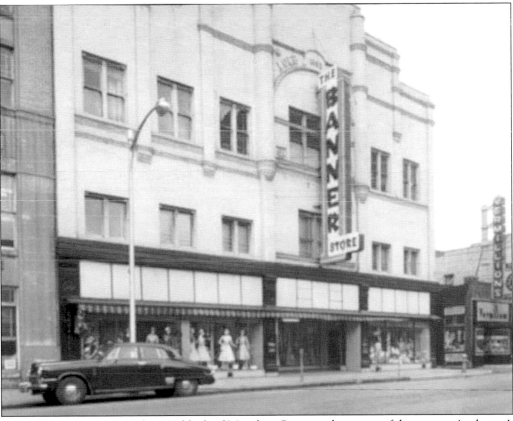

The Banner Store was in the 900 block of Meridian Street and was one of downtown Anderson's premier department stores for decades. Through the years, the store sold a variety of goods and later became a family clothing store. (Courtesy of Madison County Historical Society.)

The Anderson YMCA was founded by local businessman John Brunt. On March 26, 1915, Brunt donated $125,000 to help fund the costs of building a YMCA facility. For over 90 years, the YMCA has helped local boys polish their skills in basketball, swimming, and fellowship. It is located at Twelfth and Jackson Streets. (Photograph by Norm Cook; courtesy of the Norm Cook family.)

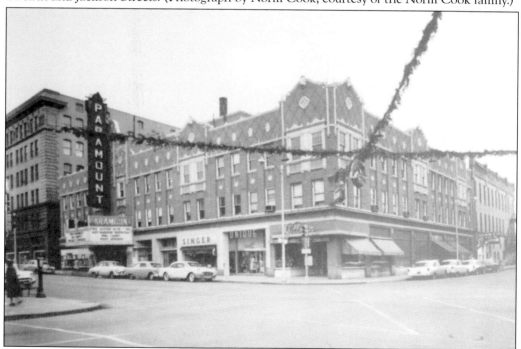

Christmas decorations stretch across Tenth and Main Streets during the 1956 holiday season. Showing at the Paramount Theatre is *Reprisal*, starring Guy Madison, and *Port Afrique*, with Pier Angeli. It was not uncommon for theaters on Meridian Street to show double features for a single admission price. To the right of the Paramount is the Unique clothing shop and Singer Sewing. (Photograph by Norm Cook; courtesy of the Norm Cook family.)

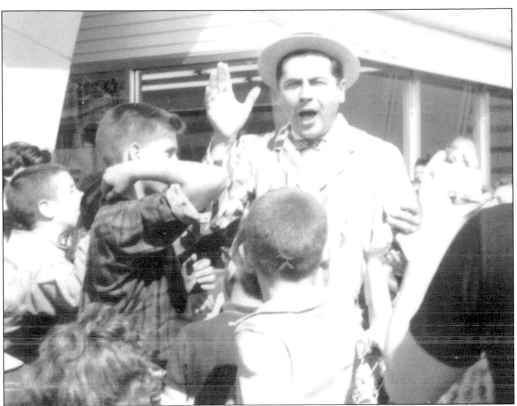

Indianapolis television celebrities Harlow Hickenlooper (above) and his sidekick, Curley Meyers (below), greet young fans and sign autographs during a 1965 visit to the McDonald's restaurant on Jackson Street in downtown Anderson. *The Harlow Hickenlooper Show* aired every Saturday morning on WFBM, channel 6. Hickenlooper joked with members of the audience, often taking a pie to the face. Meyers played guitar and sang country tunes during the two-hour program. Short films starring the Three Stooges were also featured on the popular 1960s children's television program. (Courtesy of If You Grew Up in Anderson.)

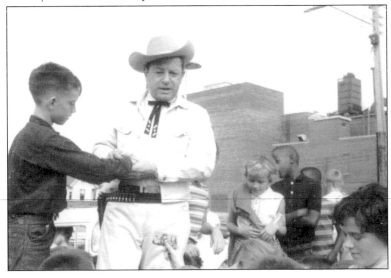

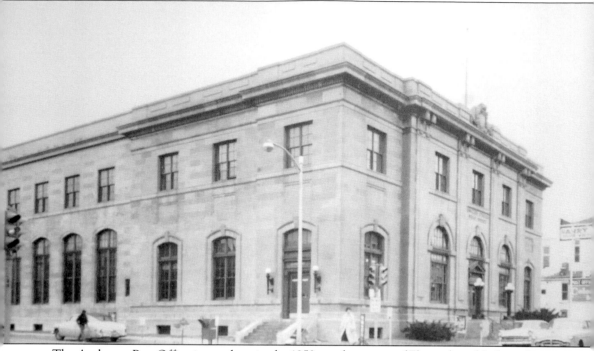

The Anderson Post Office is seen here in the 1950s, at the corner of Eleventh and Jackson Streets. After the downtown post office closed, the building was occupied by the Anderson City School Corporation Administration. Today, the old post office building serves as headquarters for Ricker's Convenience Stores. (Courtesy of Madison County Historical Society.)

Parades were held throughout the year in downtown Anderson, on both Main and Meridian Streets. Parades honored veterans, celebrated holidays, and often took place when national dignitaries came to town. This mid-1940s parade was a celebration for Independence Day. (Courtesy of the Madison County Historical Society.)

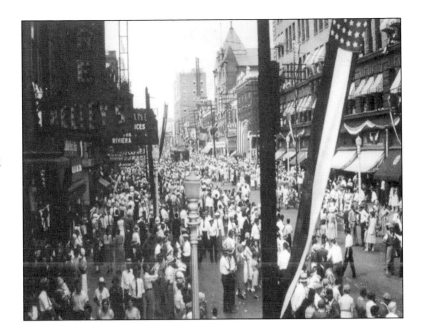

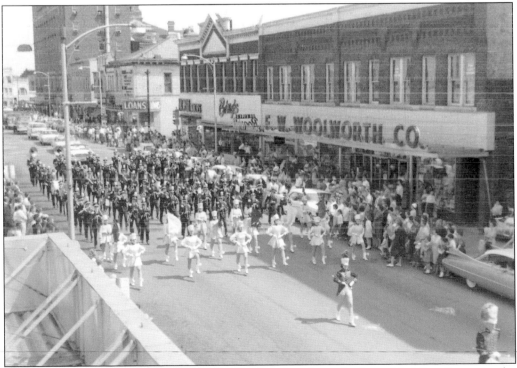

Members of the Anderson High School marching band parade down Meridian Street in the summer of 1959. Anderson High School had recently captured its third Indiana State Fair Band Day Championship. Woolworth's Department Store, Bing's Men Store, and Nobil Shoes are some of the businesses seen here. (Courtesy of the Madison County Historical Society.)

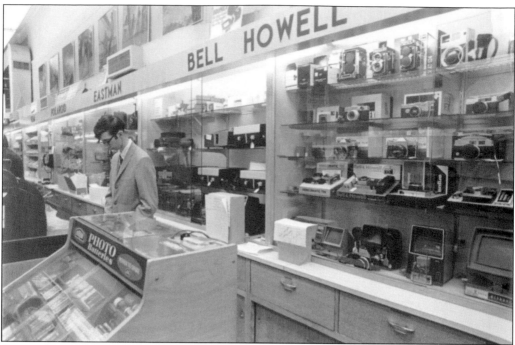

An employee of the Anderson Camera Shop runs the cash register in this photograph. Visible in the glass display case are the latest cameras and photography items from Kodak, Bell & Howell, and Polaroid. (Photograph by Harvey Riedel.)

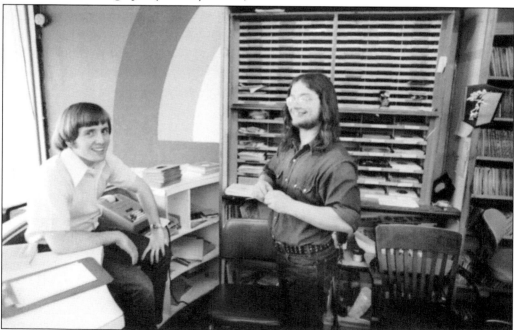

Steve Robinette (left) and Steve Butler enjoy a laugh while working at Joe's Record Shop. The popular store was owned by Joe Pike, who kept his bins stocked with the latest pop, rock, and country releases. At the time this photograph was taken, Joe's was located at Fourteenth and Meridian Streets. (Courtesy of If You Grew Up in Anderson.)

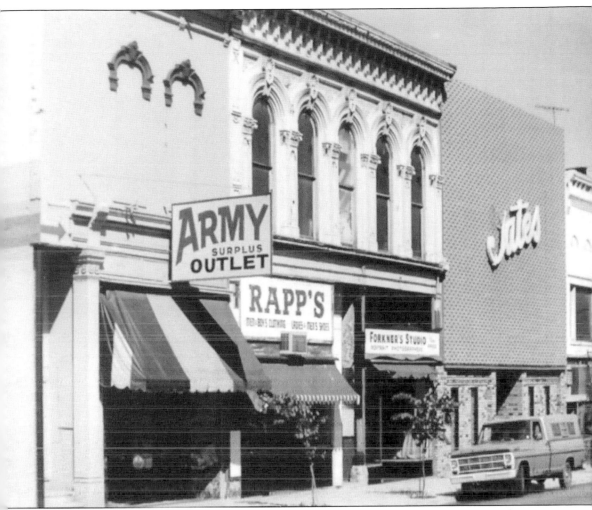

Before a devastating fire destroyed these buildings in 1978, the Army Surplus, Rapp's, Forkner's Studio, and Gates were prominent businesses in the 900 block of Meridian Street. When members of the Forkner family received word of the fire, they entered the photography studio and saved what archival photographs they could before the building burned to the ground. (Courtesy of the Madison County Historical Society.)

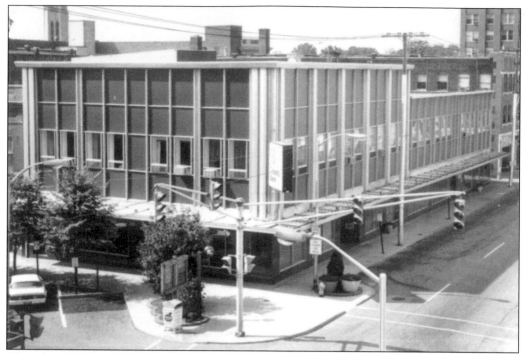

This photograph of the Citizens Bank was taken from the third floor of the parking garage at Tenth and Meridian Streets. Today, the Madison County History Center operates from this building. (Photograph by Harvey Riedel.)

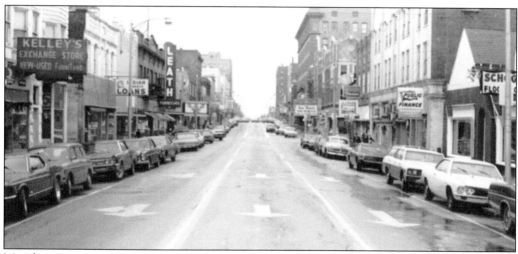

Meridian Street in downtown is seen here in the early 1970s, when it was still three southbound lanes. Within one block are three finance companies, including Public Finance and Indian Finance Loans. The Paramount and Riviera Theatres can be seen in the distance. In 1978 the roof collapsed at the Riviera Theatre, leading to the demolition of the building. (Photograph by Mike Covington.)

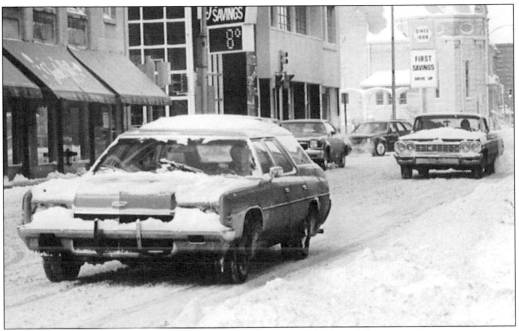

Motorists drive with caution on Jackson Street after snow blanketed the area. The temperature on the First Federal Savings sign reads eight degrees. Residents grow accustomed to such temperatures during winter months in Anderson. (Photograph by Harvey Riedel.)

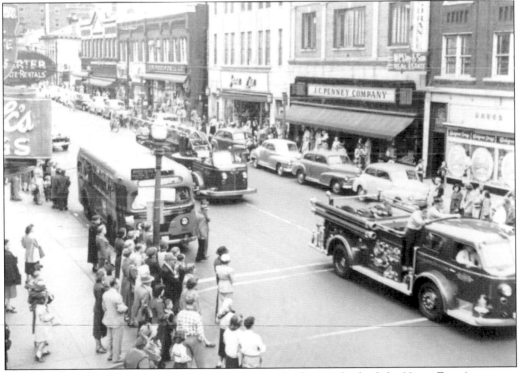

People on Meridian Street watch one of the latest city fire trucks, built by Howe Fire Apparatus in Anderson. (Courtesy of Madison County Historical Society.)

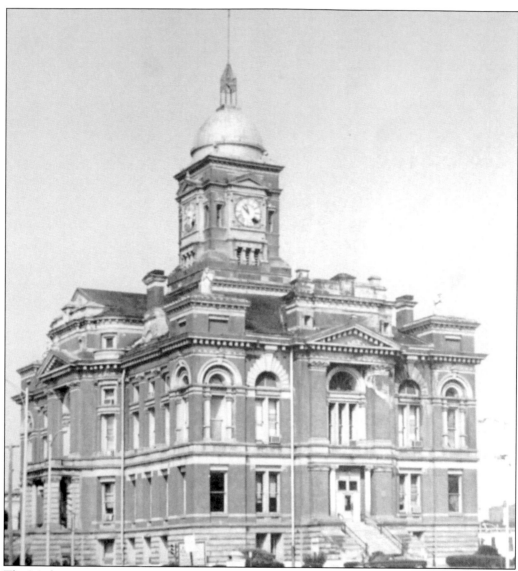

The Madison County Courthouse stands at the center of Courthouse Square on Ninth Street. This photograph of the courthouse was taken in the 1960s. When it was announced that the courthouse was to be demolished, there was a public outcry from the community. However, the razing of the historic landmark took place in 1972. After the building was torn down, residents gathered the remaining bricks for the sake of posterity. (Courtesy of the Madison County Historical Society.)

Two

PEOPLE

Nelle Levelle graduated from Saint Mary's High School in 1897. There were eight seniors in her graduating class. In 1966, Saint Mary's closed its doors due to lack of funds. The remaining students transferred to Anderson High, Madison Heights High, and Highland High School. (Courtesy of Saint Mary's Catholic School.)

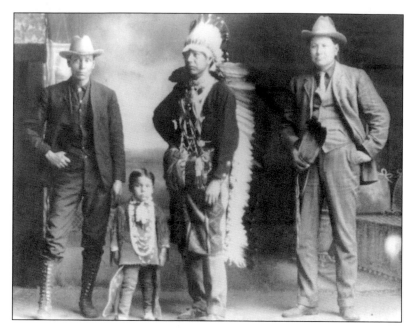

Shown here are, from left to right, John, George, Sam, and Andrew Anderson. They are descendents of Chief Anderson, who settled in Anderson in 1798. This portrait of the Anderson family was taken in 1909. (Courtesy of If You Grew Up in Anderson.)

Members of the Castor family pose for a photograph in the early 1900s. They are, from left to right, (seated) Florida Castor, Hezakiah Robinette, and Orel Robinette; (standing) Freelore Abney, Angeline Castor, Sadie Castor, Allie Robinette, and Nancy Sylvester. (Courtesy of George Humphrey.)

36

Members of the 1890 Anderson High School student body pose for a photograph outside the school. The class consisted of 43 students and 2 instructors. (Courtesy of the Anderson Public Library.)

Anderson firemen pose outside the No. 2 Company, located at Seventeenth Street and Madison Avenue. They are, from left to right, (seated) George Parson and Chief Samuel Towel; (standing) James Hartley, Capt. Caleb Shinkle, and Ira Keeley. This photograph was taken in 1890. (Courtesy of the Madison County Historical Society.)

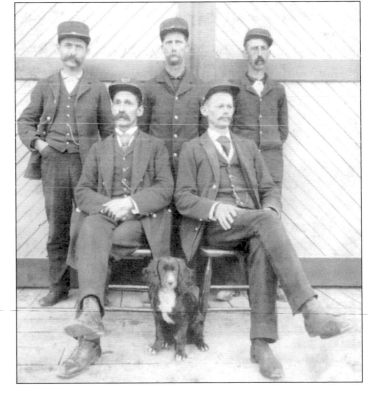

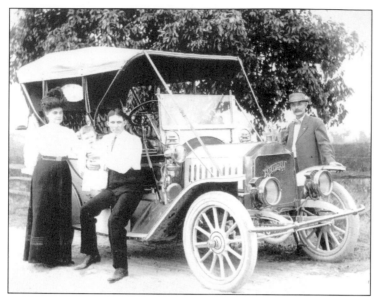

A family poses with their newly purchased Lambert automobile in the early 1900s. The Lambert was manufactured in Anderson from 1906 to 1917. John William Lambert designed the car, produced at the Buckeye Manufacturing Company on Columbus Avenue. (Courtesy of the Madison County Historical Society.)

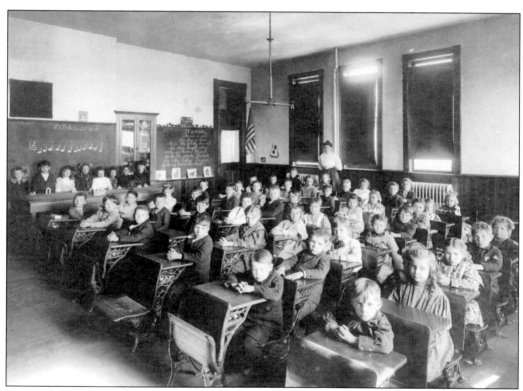

Roosevelt Elementary School was an Anderson Township school at Fifty-third Street and Madison Avenue on the south side of town. Roosevelt Elementary later became a member of the Anderson Community School System and closed in the late 1970s. The school was named after Pres. Theodore Roosevelt, and its athletic teams were known as the Roughriders. This photograph of an unidentified class was taken on October 21, 1907. (Courtesy of the Anderson Public Library.)

The Central
Indiana Gas
Company had
its offices on
Eighth and
Jackson Streets
in Anderson.
This photograph
was taken at the
1915 summer
company picnic,
held at Idlewold
Park in Pendleton.
(Courtesy of
the Anderson
Public Library.)

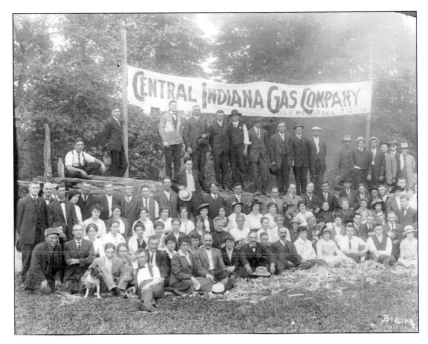

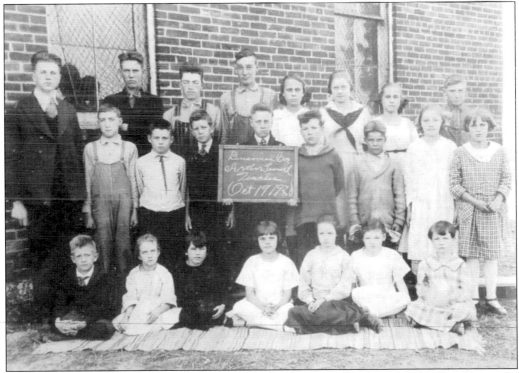

Students of the Business Corner School pose for a portrait on October 19, 1920. Standing at far left is instructor Arthur Leonard. (Courtesy of the *Anderson Herald Bulletin*.)

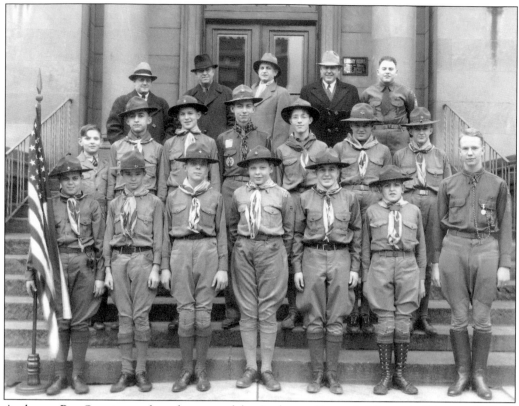

Anderson Boy Scouts stand on the steps of the Anderson Carnegie Library in February 1938 for a troop photograph. (Courtesy of the Anderson Public Library.)

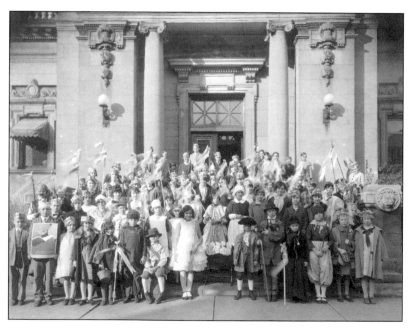

Vacation Reading Club members were invited to a National Book Week party at the Anderson Carnegie Library in November 1926. The children in costumes were characters from the play *Book Land*. (Courtesy of the Anderson Public Library.)

Famed Hoosier poet James Whitcomb Riley lived in Anderson in the 1870s. While in Anderson, Riley found work as a reporter for the *Anderson Democrat* newspaper. His poems appeared regularly in the *Anderson Democrat*, with illustrations provided by artist Samuel Richards. In 1877, Riley carried out his famous hoax, passing off his poem "Leonanie" as a work by Edgar Allen Poe. After much local and national criticism, Riley left Anderson and began writing for the *Indianapolis Journal*. He returned to Anderson in 1913, where he was honored in a parade. (Courtesy of the Anderson Public Library.)

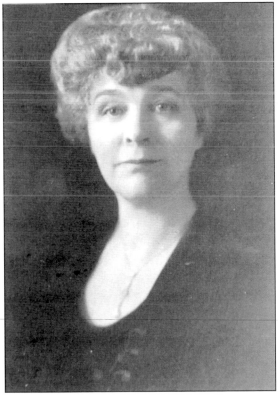

Harriet Toner was a dominant force in Anderson civic affairs. In 1913, she spearheaded the Anderson Council of Women. The council's accomplishments included establishing the first Parent-Teacher Association of the city of Anderson and lobbying to appoint a woman to the school board. Toner's husband, Edward, was editor and publisher of the *Anderson Herald*. When he died in 1927, she assumed leadership of the newspaper. Toner has been recognized as a pioneer in the Anderson-area women's movement. (Courtesy of the Anderson Public Library.)

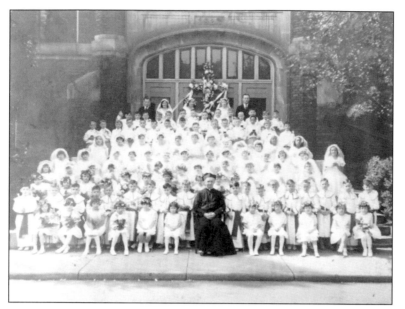

Monsignor Travers sits with the Saint Mary's Catholic Church communion class of 1947. Saint Mary's, located at 1115 Pearl Street, was established in 1866. (Courtesy of Saint Mary's Catholic Church.)

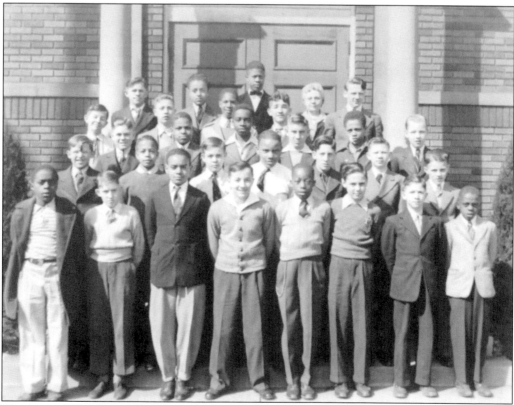

The boys of Hazelwood Elementary's class of 1940 stand on the school steps for a photograph. Hazelwood was built in 1892 in the 2300 block of Madison Avenue. After Hazelwood closed in the 1980s, the Wilson's Boys and Girls Clubs of America utilized the facility for Anderson-area youths. (Courtesy of the Urban League of Madison County.)

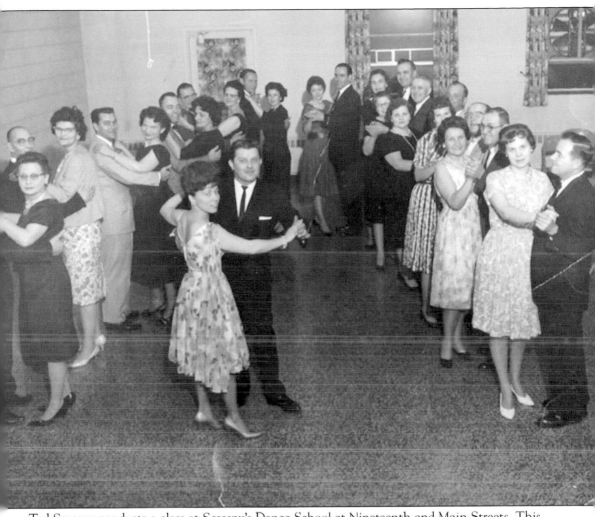

Ted Sczesny conducts a class at Sczesny's Dance School at Nineteenth and Main Streets. This 1962 photograph shows Sczesny (front center) teaching his students the latest steps on the dance floor. (Courtesy of If You Grew Up in Anderson.)

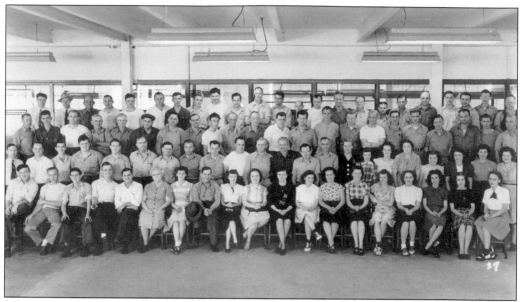

Workers at Delco-Remy Plant 6 gather for a department photograph in the early 1940s. It was not uncommon for photographers to take portraits of factory workers for historical purposes or to be sold to employees. (Courtesy of George Humphrey.)

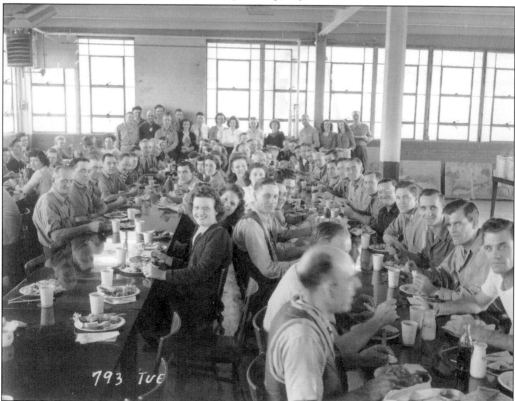

This early 1940s photograph shows first-shift Delco-Remy employees enjoying lunch in the factory cafeteria. (Courtesy of George Humphrey.)

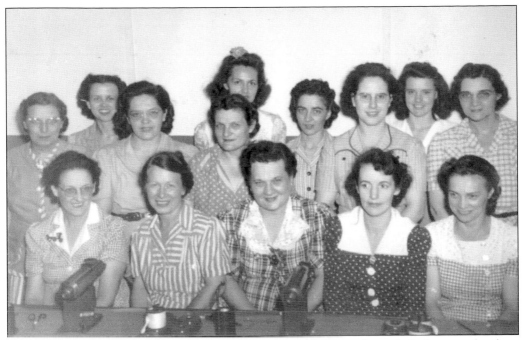

These women take a break from the Delco-Remy assembly line to have their photograph taken. (Courtesy of George Humphrey.)

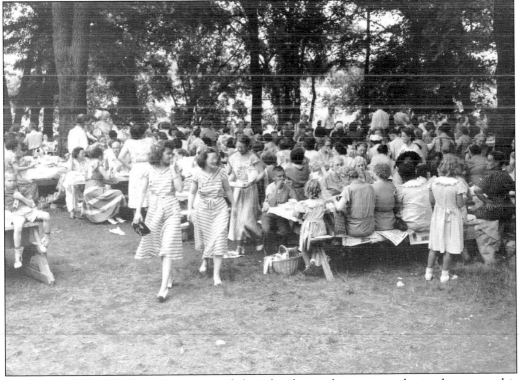

Employees of Ward Stilson Company and their family members enjoy a day in the sun at this 1935 picnic. (Courtesy of the Anderson Public Library.)

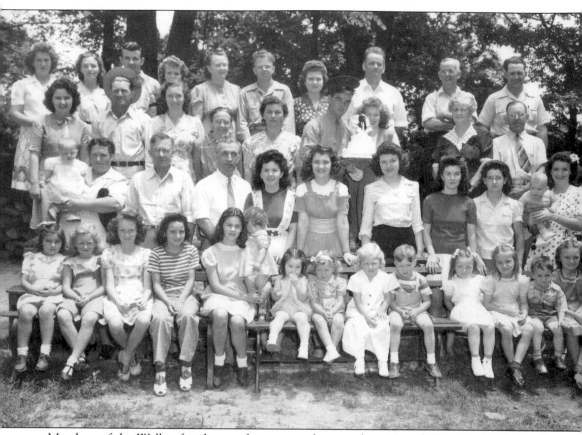

Members of the Walker family pose for a group photograph at Mounds State Park. The Walker family hailed from Burkesville, Kentucky, and moved to Anderson in the 1930s to enjoy a more prosperous life. (Courtesy of George Humphrey.)

Picketing at Guide Lamp was often conducted by members of the entire family when workers went on strike. Here, women from the plant stand outside the General Motors automobile factory supporting the UAW Local 663 union and its decision to shut down production. From left to right are (seated) Lenora Collins and Mable Williams with two unidentified boys; (standing) Mary Langford, Nettie Freeman, Lois White, Elsie Rogers, Helen Brauchla, Jewell Poteel, and Jewel Schock. (Courtesy of UAW Local 663.)

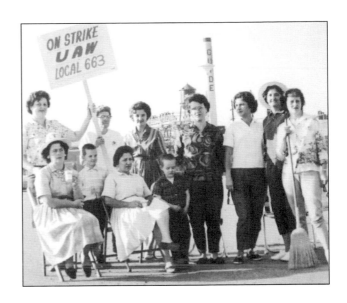

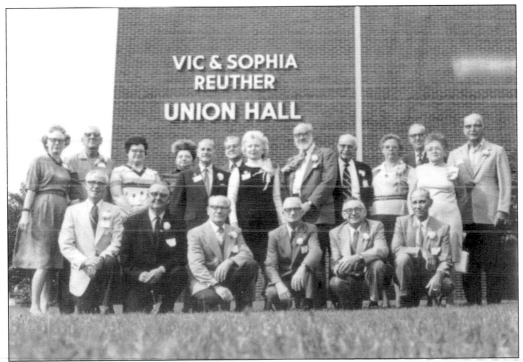

Members of the 1936 Guide Lamp sit-down strike reunited at the UAW Local 663 Union Hall in the late 1970s. The union hall is named in honor of Victor and Sophia Reuther, who helped organize the historic event that led to the establishment of UAW 663. Victor Reuther is the gentleman with the white beard standing in the back row. His wife, Sophia, is to the left of him. (Photograph by Harvey Riedel.)

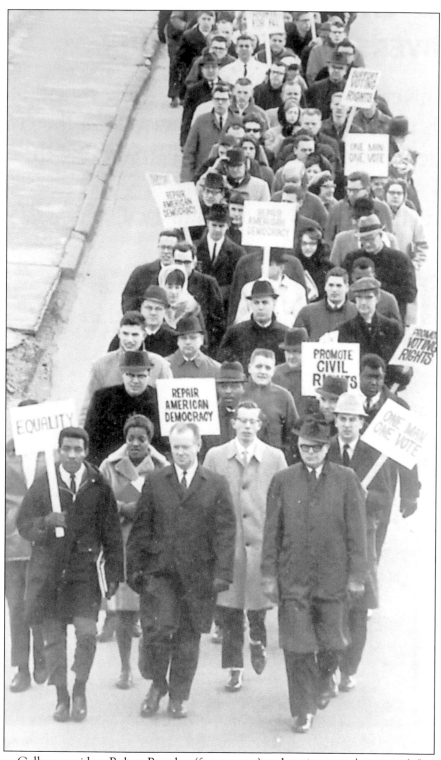

Anderson College president Robert Reardon (front center) and seminary students march for equality during the civil rights movement of the 1960s. (Courtesy of the *Anderson Herald Bulletin*.)

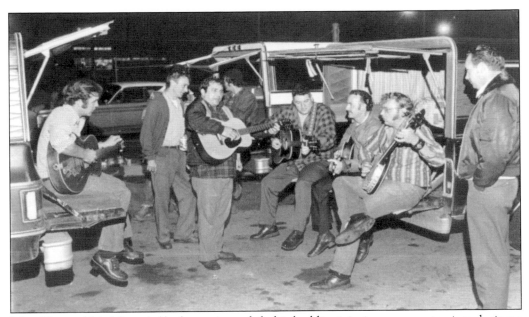

John Hewitt (third from left) plays guitar while his buddies join in on a country jam during a strike held at Delco Remy Plant 19. Hewitt and friends are gathered in the factory parking lot (Photograph by Harvey Riedel.)

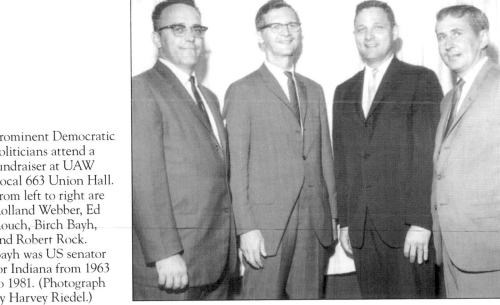

Prominent Democratic politicians attend a fundraiser at UAW Local 663 Union Hall. From left to right are Rolland Webber, Ed Rouch, Birch Bayh, and Robert Rock. Bayh was US senator for Indiana from 1963 to 1981. (Photograph by Harvey Riedel.)

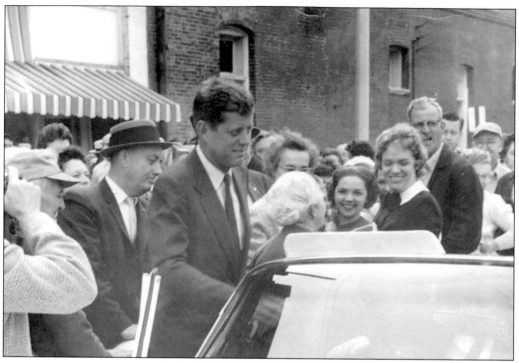

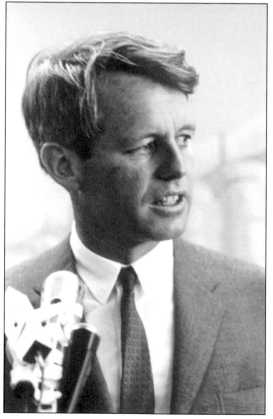

While seeking the Democratic nomination for president, Massachusetts senator John F. Kennedy spoke to a large crowd at the Madison County Courthouse on April 7, 1960. Supporters of the presidential hopeful arrived at the courthouse as early as 4:00 a.m. on the day of his appearance. (Photograph by Harvey Riedel.)

On May 1, 1968, New York senator Robert F. Kennedy campaigned in Anderson, as his brother John did eight years earlier. Kennedy spoke to over 1,800 people at the Anderson High School Wigwam gymnasium while running for president during the Indiana Democratic primary. After his speech, Kennedy stayed past midnight, signing autographs and meeting with supporters. Kennedy went on to win Indiana. He was assassinated one month later while campaigning in Los Angeles. (Photograph by Harvey Riedel.)

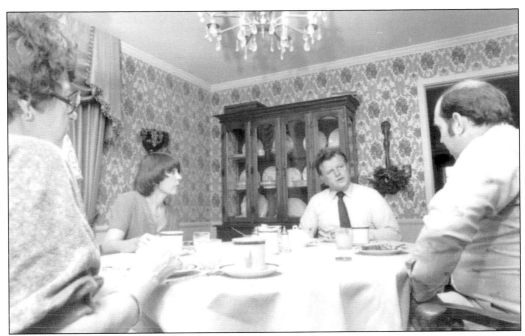

Massachusetts senator Ted Kennedy speaks with supporters at the home of UAW Local 663 president Ray Tierney. Kennedy appeared in Anderson on May 3, 1980, while running against sitting president Jimmy Carter, who went on to represent the Democratic party in the November election. (Photograph by Harvey Riedel.)

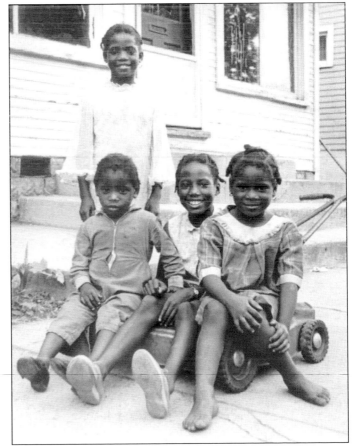

These youngsters pose with a lawn mower while having their photograph taken on the city's west side. (Photograph by Harvey Riedel.)

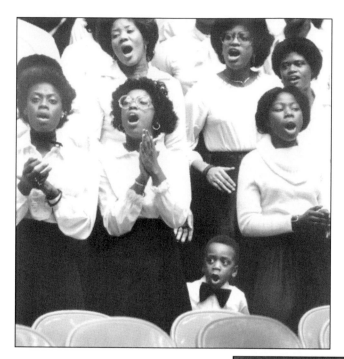

The church has always played a prominent role in the lives of black families in the Anderson area. Here, a choir sings hymns at a Sunday morning service. (Photograph by Harvey Riedel.)

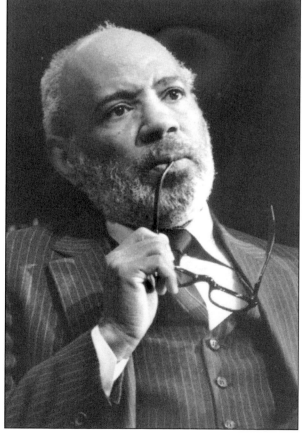

James Meredith made an appearance in Anderson in the early 1980s, speaking at the Paramount Theatre and visiting the Martin Luther King Jr. statue on Madison Avenue. In 1962, Meredith was the first black student to attend the segregated University of Mississippi. Today, the 80-year-old civil rights activist lives in Jackson, Mississippi, with his wife, Judy. (Photograph by Harvey Riedel.)

Republican presidential hopeful Ronald Reagan spoke at the UAW Local 662 Union Hall on April 28, 1976. The event was hosted by the Lincoln Club of Anderson. Reagan lost his presidential bid to Pres. Gerald Ford, but went on to win the presidency in 1980 and 1984. (Photograph by Harvey Riedel.)

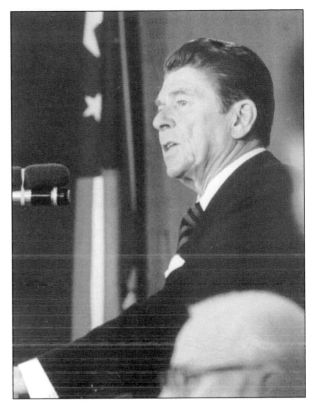

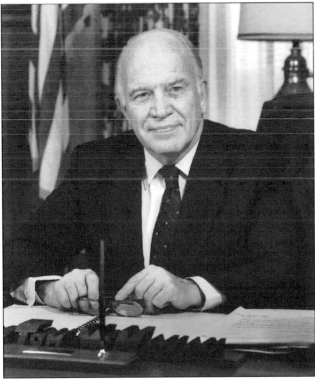

Thomas McMahan was a popular Anderson mayor who held office from 1980 to 1987. He later served on the board of directors for the United Way and the Madison County Community Foundation, and helped to establish the River Walk around White River. McMahan passed away in 1999. (Photograph by Harvey Riedel.)

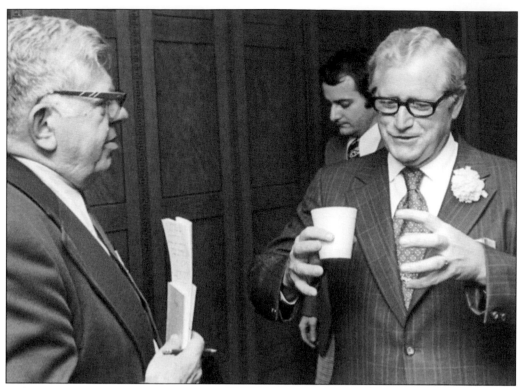

Anderson newspaper reporter Leo Lortz (left) interviews Indiana governor Otis Bowen during a late 1970s visit to Anderson. Lortz was known as a hard-nosed reporter who sought the facts and used them in his stories. (Photograph by Harvey Riedel.)

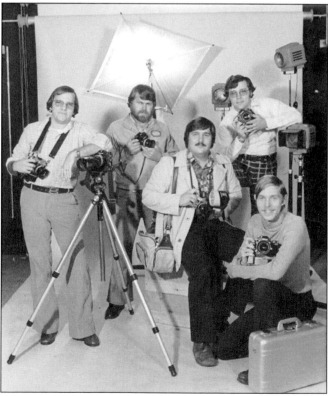

Anderson Bulletin and *Anderson Herald* photographers pose for a group portrait between assignments. From left to right are (seated) Jim Brown and Greg White; (standing) Steve Hagensacker, Harvey Riedel, and John Cleary. (Courtesy of Harvey Riedel.)

Members of the Beta Sigma Phi sorority help promote the Little 500 and the Indianapolis 500, held at the Anderson Sun Valley Speedway and the Indianapolis Motor Speedway, respectively, in May. Clockwise from lower left are Paula Ramsey, Susan Closser, Barb Rinker, Beth Furnish, and Shirley Harvey. (Photograph by Harvey Riedel.)

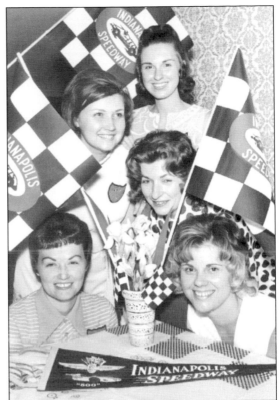

Miss America 1970 Pam Aldred talks with Anderson police officer John Gunter at the grand opening of Saxon Oldsmobile in Anderson. The car dealership, located at 5400 South Scatterfield Road, is now the home of Ed Martin Autos. (Photograph by Harvey Riedel.)

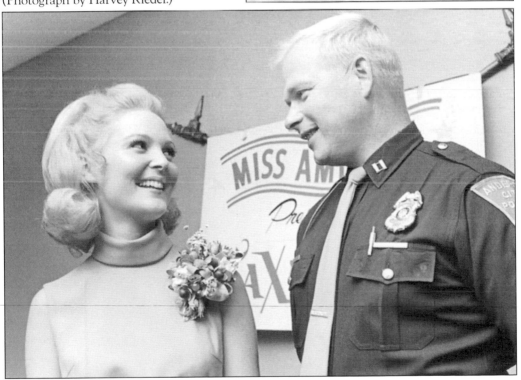

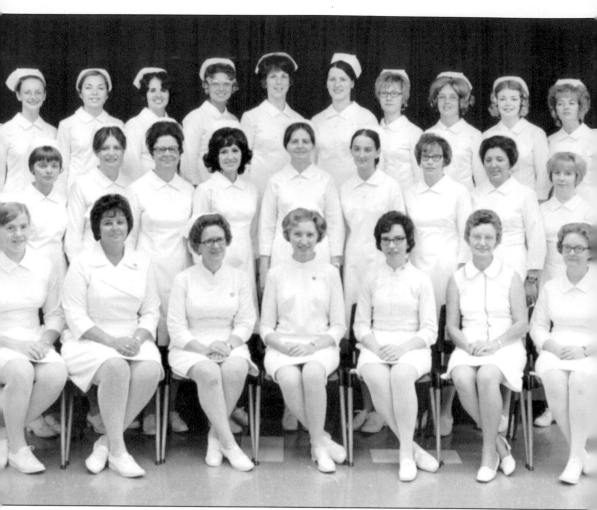

Graduates of the Licensed Practical Nurse (LPN) program at the Anderson Area Vocational School pose for a 1971 class portrait. This was the first LPN graduating class at the vocational school, located near Thirty-eighth and Brown Streets. (Photograph by Harvey Riedel.)

Three

SPORTS AND
ENTERTAINMENT

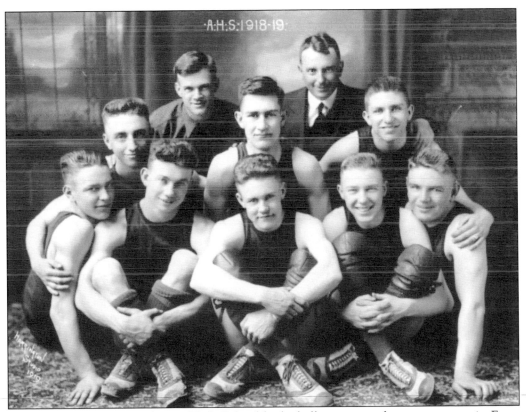

Members of the 1919 Anderson High School basketball team pose for a team portrait. From left to right are (first row) Thamer Main, Orville Hooker, Arthur Brown, Earl Bell, and Adam Wolski; (second row) Earl Grissmer, Arthur Dykins, and Jerrold Gale; (third row) Coach Staggs and manager McClintock. (Courtesy of the Anderson Public Library.)

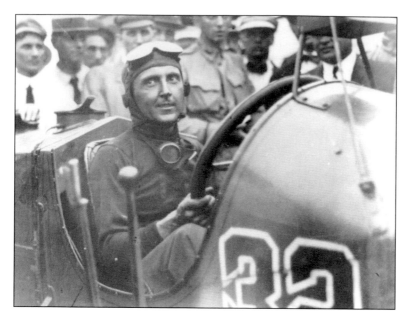

Ray Harroun won the inaugural Indianapolis 500 in 1911. He lived in Anderson at the time of his death in 1968. Harroun was laid to rest at Anderson Memorial Park Cemetery. (Courtesy of If You Grew Up in Anderson.)

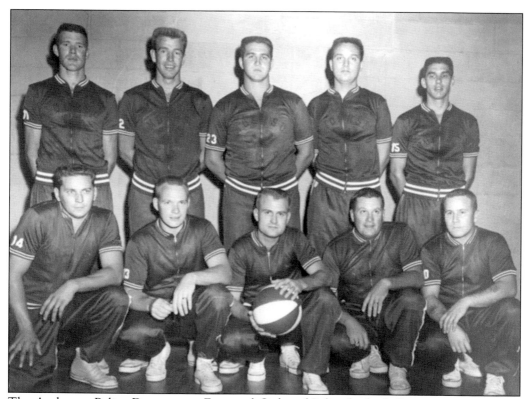

The Anderson Police Department Fraternal Order of Police basketball team was 1959 state champions in a tournament featuring law enforcement agencies from Indiana. Shown here are, from left to right, (first row) Charles Skinner, John Gunter, Harry Chappell, Bob Tumalty, and "Pug" Vaughn; (second row) John Rogers, Phil Seybert, Moses Beeman, Duke Mengelli, and Don Bates. (Courtesy of If You Grew Up in Anderson.)

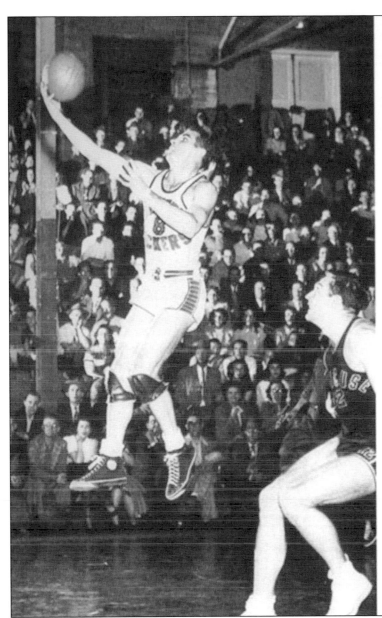

Frank Brian lead a fast break for the Packers.

The guard from Louisiana State University was Second Team all NBA in 1950

Frank Brian puts two points on the scoreboard for the Anderson Packers. The Packers played their home games at the Anderson High School Wigwam. From 1946 to 1949, the Packers were members of the National Basketball League, before playing in the National Basketball Association (1949–1950). When the NBA was absorbed by the league, the Packers moved to the National Professional Basketball League. (Courtesy of If You Grew Up in Anderson.)

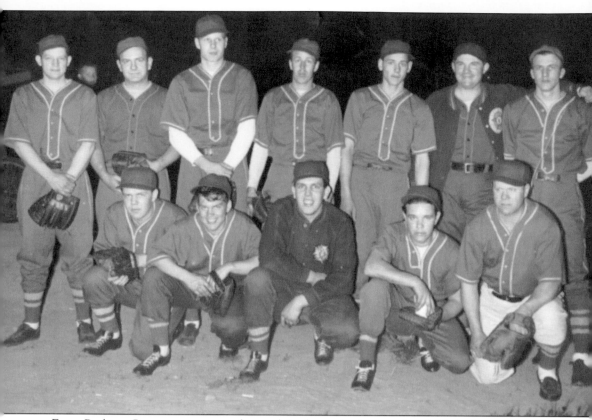

Emge Packing Company was one of several Anderson businesses that fielded a fast-pitch softball team, which played in the Industrial League at Shadyside Park. Emge Packing placed fourth in the 1951 Anderson Industrial Softball Division. UAW-CIO 662 finished first, with a perfect record of 15 wins and no losses. (Courtesy of George Humphrey.)

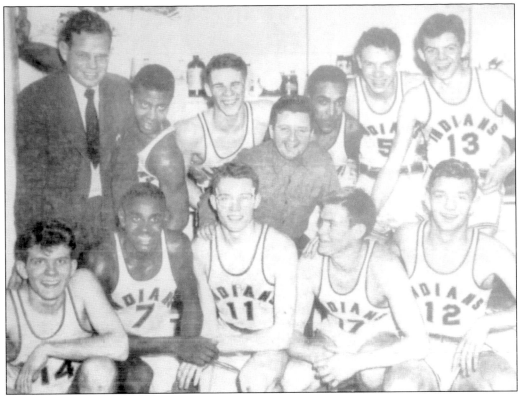

The Anderson High School Indians boys' basketball team celebrates in the locker room after winning the 1946 Indiana High School Athletic Association state finals tournament at Hinkle Fieldhouse in Indianapolis. Shown are, from left to right, (first row) Bob Ritter, Johnny Wilson, Bob Spearman, Harry Farmer, and Don Armstrong; (second row) coach Charles Cummings, Ike Weatherly, Jim Vandebur, assistant coach Carl Bonge, John Cochrane, Dick Roberts, and Clyde Green. Wilson was named Mr. Basketball for that year. (Courtesy of the *Anderson Herald Bulletin*.)

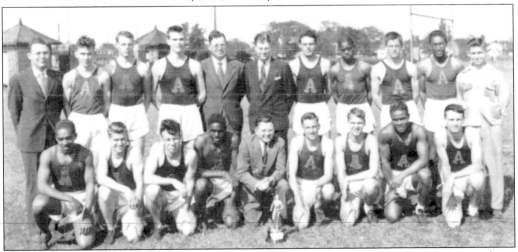

The Anderson High School Indians won the Indiana High School Athletic Association boys' state tournament in the years 1945, 1946, 1947, and 1948. The team was led by coach Carl Bonge. (Courtesy of Anderson High School.)

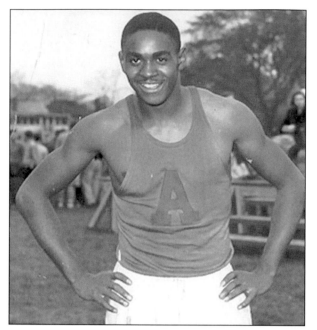

Johnny Wilson was born in Anderson in 1927 and is a 1946 graduate of Anderson High School. Wilson was not only a great basketball player in high school, but also excelled at baseball and track and field. After his four-year stint at Anderson High School, Wilson attended Anderson College, where he earned a bachelor's degree in education. During his years as a professional athlete, Wilson played for the Chicago American Giants in the Negro Leagues and for the Harlem Globetrotters from 1949 to 1954. Wilson coached basketball at Wood High School in Indianapolis and later at Malcolm X College in Chicago. He is a member of the Indiana Basketball Hall of Fame. (Courtesy of Anderson High School.)

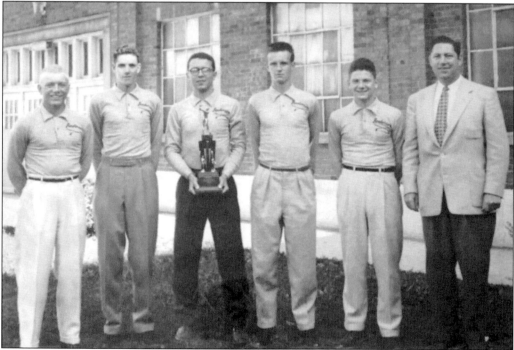

The Anderson High School golf team was crowned champions at the 1953 Indiana High School Athletic Association golf state finals. The team included, from left to right, Joe Campbell, Don Granger, Jerry Higgenbotham, Ted Boots, Dave Brown, and Coach Jim Carter. Campbell went on to play golf for Purdue University and won the 1955 NCAA golf championship. After turning pro in 1959, he placed first in 15 PGA tournaments and was a member of the 1959 Walker Cup team. In 1969, Campbell was inducted into the Indiana Golf Hall of Fame. (Courtesy of Anderson High School.)

Carl Erskine was born on December 13, 1926, and graduated from Anderson High School in 1945. After a successful stint as a pitcher for the Anderson Indians, Erskine began his major-league career with the Brooklyn Dodgers in 1948. Over the next 11 years, Erskine pitched no-hit games against the Chicago Cubs (1952) and the New York Giants (1956), and was a member of the 1955 Brooklyn Dodgers World Series championship team. In 1954, Erskine was selected to the National League All-Star team. He retired from baseball in 1959 with a record of 122 wins and 78 losses. (Courtesy of Carl Erskine.)

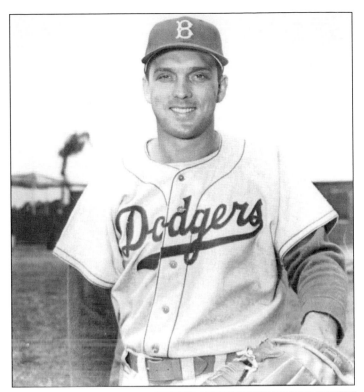

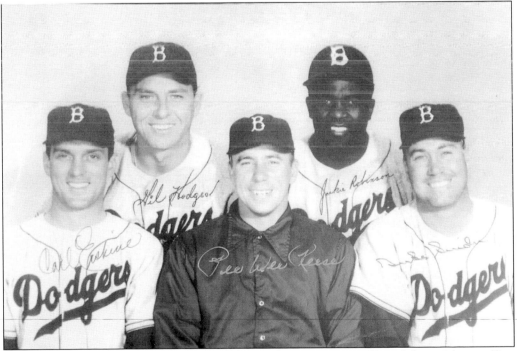

Carl Erskine poses with some of his Brooklyn Dodgers teammates. From left to right are (first row) Erskine, Pee Wee Reese, and Duke Snider; (second row) Gild Hodges and Jackie Robinson. (Courtesy of Carl Erskine.)

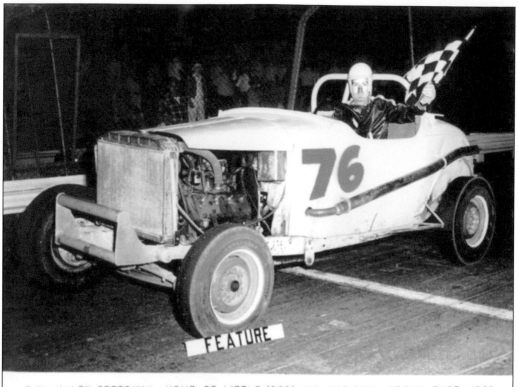

SUN VALLEY SPEEDWAY – HOME OF LITTLE '500' AND NATIONAL CROWN RACE – 1959
ANDERSON, INDIANA

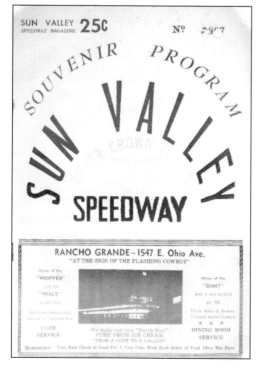

Sun Valley Speedway was founded in 1948 by racing promoter Joe Helpling. The Roaring Roadsters and AAA Midgets were the most popular events in the track's inaugural season. The following year, Sun Valley Speedway was the site of the first Little 500 race. The 1949 event included 33 roadsters. It was won by Sam Skinner. Today, the track is known as the Anderson Speedway and is located at Twenty-ninth Street and Martin Luther King Jr. Boulevard. (Courtesy of If You Grew Up in Anderson.)

Shown here is a program for the 1953 Silver Crown Classic, held at Sun Valley Speedway. (Courtesy of If You Grew Up in Anderson.)

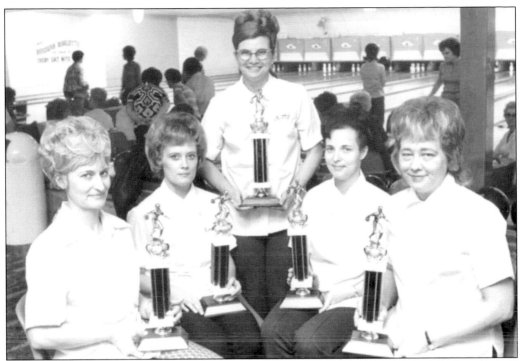

Phyllis Boles (center) and members of the UAW 663 women's bowling team pose with their trophies after winning first place at a tournament at Cooper's Sport Bowl. (Photograph by Harvey Riedel.)

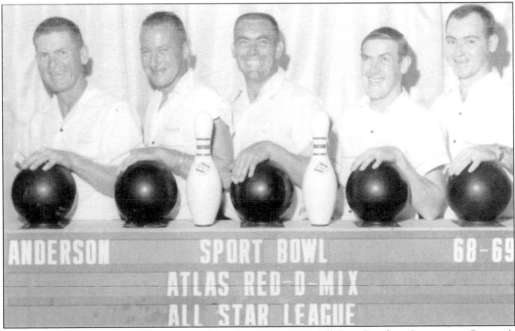

The Atlas Red-D-Mix team competed in the 1968–1969 All-Star Bowling League at Cooper's Sport Bowl. (Courtesy of If You Grew Up in Anderson.)

A member of the Franklin All-Stars team slides into second base ahead of the tag during their Little League contest against the White River All-Stars. (Photograph by Harvey Riedel.)

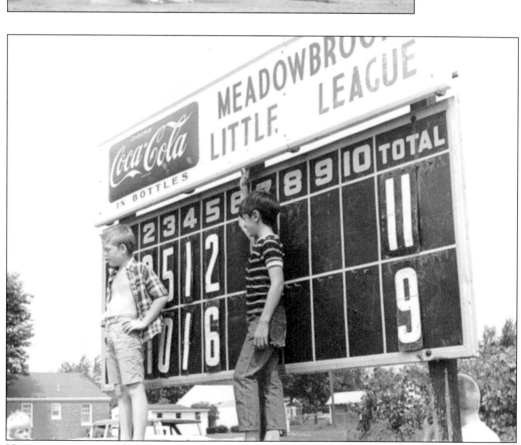

Here, two youngsters keep score in the summer of 1965 at Meadowbrook Little League. During the 1960s, there were several Little League organizations throughout the city of Anderson. Meadowbrook Little League was located on the corner of Brown Street and South Drive in the Meadowbrook neighborhood. In the mid-1970s, Meadowbrook Little League relocated to a new playing field in the 4500 block of South Main Street. (Photograph by Harvey Riedel.)

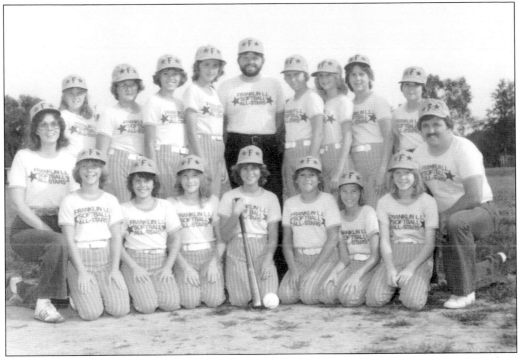

During the late 1970s, softball leagues formed in Anderson, giving girls the chance to show their athletic skills on the diamond. The Franklin Little League Softball All-Stars pose for a team picture in 1981. Franklin Little League games were held on a diamond at Franklin Elementary School at Thirty-eighth Street and the 109 Bypass. (Photograph by Harvey Riedel.)

Jim Herbert and his mother talk with promoters of the Anderson Soap Box Derby after the youngster won the 1965 racing event. The Anderson derby, still a popular event, is held every summer at Derby Downs on North Madison Avenue. (Photograph by Harvey Riedel.)

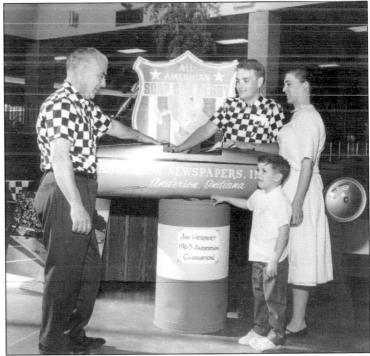

Sponsored by
MADISON HEIGHTS BAND BOOSTERS

Home of the
Pirates

Long before the term "Friday Night Lights" was introduced, football fans had their choice of Anderson high school teams to support during the fall season. This program, for a 1969 Madison Heights Pirates home game, was sponsored by the Madison Heights Band Boosters Club. (Courtesy of If You Grew Up in Anderson.)

Members of the Anderson High School cheerleading squad don knit caps and sweaters during an Indians home football game. (Photograph by Harvey Riedel.)

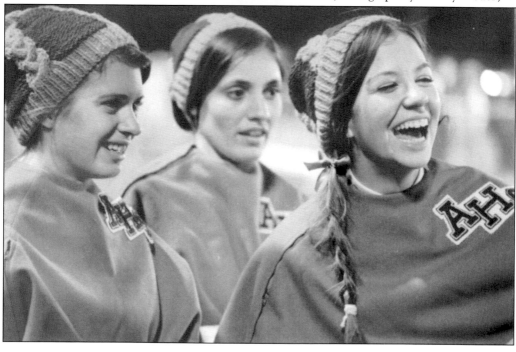

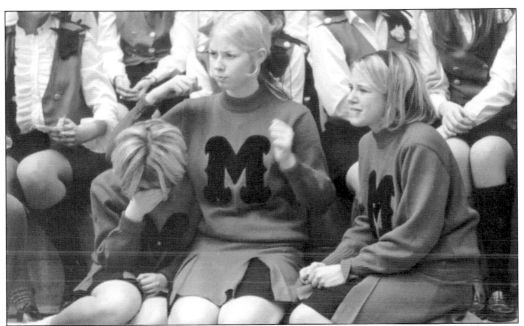

Cheerleading played an integral role during the heyday of the Anderson High School Basketball Sectional. Up to 8,000 fans attended the popular sporting event, held in February at the Anderson High School Wigwam. Students filled the lower section of the Wigwam, with the upper section reserved for adults. The Madison Heights Pirates played the Anderson Indians during the championship game of the 1969 sectional. The Indians won the title game against their crosstown rival. Emotions ran high among members of the cheerleading squads and fans in the stands. These photographs capture the highs and lows of the Madison Heights cheerleaders during the 1969 championship game. (Photographs by Harvey Riedel.)

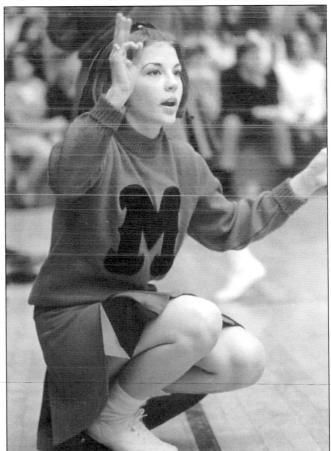

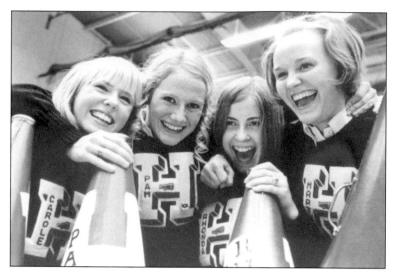

Highland High School cheerleaders are all smiles after the Scots won the 1976 Anderson Basketball Sectional. The Scots went on to win the Anderson regional that year, but were defeated the following week at the semi-state tournament. (Photograph by Harvey Riedel.)

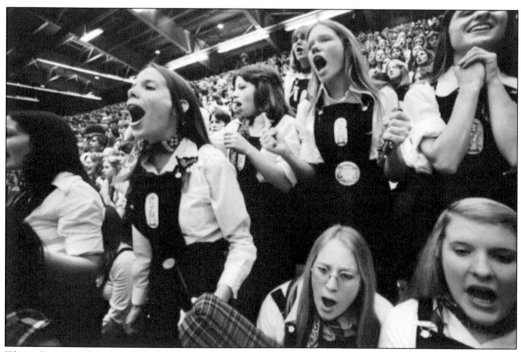

This photograph of the Highland High School student section captures the excitement of the Anderson Basketball Sectional. Anderson High School, Madison Heights High School, and Highland High School have a combined total of over 60 sectional championships. (Photograph by Harvey Riedel.)

Madison Heights starting forward Bobby Wilkerson puts two points on the scoreboard for the Pirates. In 1972, Wilkerson led the Pirates to the IHSAA state finals, held at Assembly Hall at Indiana University in Bloomington. Wilkerson went on to play for the Indiana Hoosiers and was a member of the 1976 NCAA championship team under legendary coach Bobby Knight. (Photograph by Harvey Riedel.)

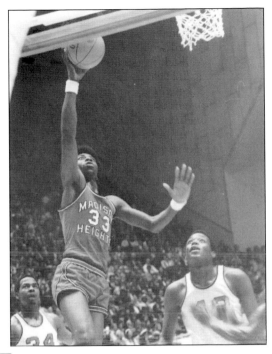

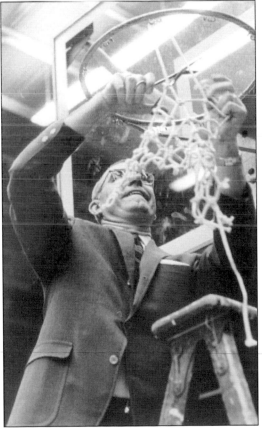

Madison Heights varsity basketball coach Phil Buck cuts down a piece of the net after the Pirates won the 1975 Anderson Basketball Sectional. During his 20-plus years as head coach of the Pirates, Buck led the team to nine sectional titles, one regional title, and one semi-state title, as well as a trip to the 1972 state finals. Coach Buck was inducted into the Indiana Basketball Hall of Fame in 1983. (Photograph by Harvey Riedel.)

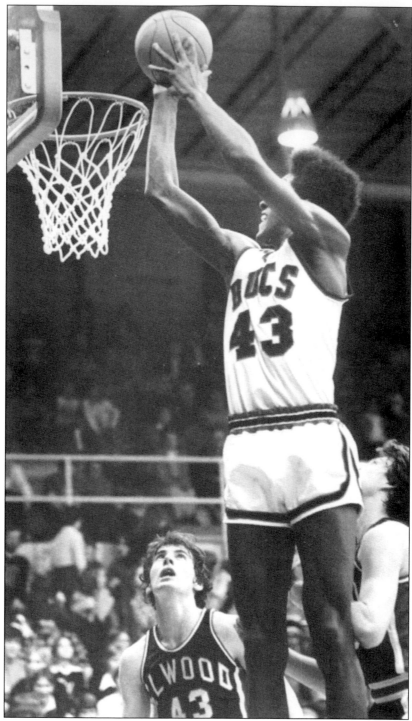

Ray Tolbert was starting center for the Madison Heights Pirates and was named Indiana's Mr. Basketball in 1977. Tolbert played for the Indiana University squad that won the 1981 NCAA basketball tournament. He was drafted by the New Jersey Nets of the National Basketball Association before dedicating his life to the ministry. (Photograph by Harvey Riedel.)

Jim Regenold graduated from Madison Heights in 1968 and was a member of the 1967 and 1968 Pirates basketball team that won the Anderson Sectional. After graduating from high school, Regenold attended Ball State University in Muncie, where he played for the Cardinals basketball team. He was named team captain and Most Valuable Player in 1971 and 1972. Today, Regenold is principal of Alexandria Monroe High School in Alexandria. (Photograph by Harvey Riedel.)

Bob Fuller was one of the most successful coaches in the history of Indiana basketball. During his illustrious career as a boys' basketball coach, Fuller compiled a record of 256 wins and 60 losses. He led Highland High School to its first sectional and regional titles in 1976. On January 11, 1980, Bob Fuller died from a heart attack while coaching the Highland Scots during a home game against the Lapel Bulldogs. (Photograph by Harvey Riedel.)

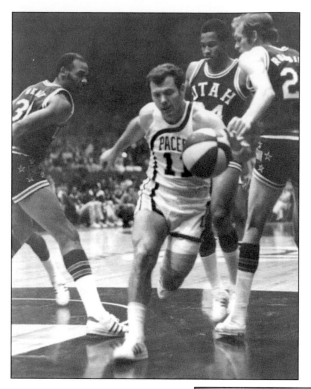

In 1967, the Indiana Pacers became a part of the American Basketball Association (ABA). The Indianapolis State Fairgrounds Coliseum served as home court for the Pacers through 1974. The team later played at Market Square Arena in downtown Indianapolis. In 1968 and 1969, the Pacers played several games at the Anderson High School Wigwam. The Pacers were crowned champions of the ABA in 1970, 1972, and 1973. Roger Brown and Mel Daniels, who played for the Pacers during the ABA era, are members of the National Basketball Hall of Fame. In 1976, the Pacers joined the National Basketball Association. At left, Pacers guard Billy Keller drives toward the basket during a game against Utah. Below, Freddie Lewis looks for an open teammate to pass to during that same contest. (Photographs by Harvey Riedel.)

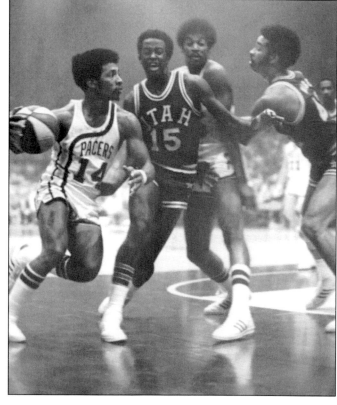

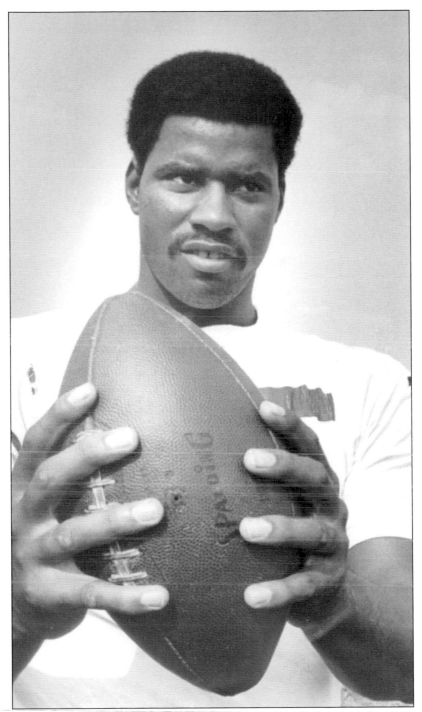

Ken Johnson is a graduate of Anderson High School, where he excelled in football. After graduating, he attended college at Indiana University. In 1971, Johnson was drafted by the Cincinnati Bengals of the National Football League. As a member of the Bengals, Johnson played defensive tackle for eight seasons. Before retiring in 1978, he appeared in 80 games for the Bengals, wearing No. 80. (Photograph by Harvey Riedel.)

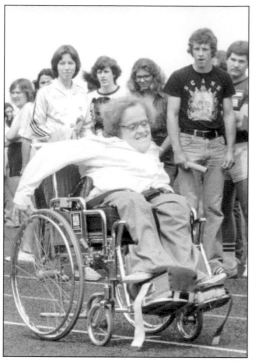

The Madison County Special Olympics has made it possible for the mentally and physically challenged to enjoy sporting events. Basketball, softball, swimming, and bowling are offered to Madison County Special Olympians throughout the year. But it is the annual track-and-field event, held every spring at Anderson University, that draws the largest number of athletes and volunteers. After taking a parade lap around the university track, Special Olympians compete in the 100-yard dash, softball throw, standing broad jump, and the long jump. At left, a Special Olympics athlete is greeted with cheers as she crosses the finish line. Though hundreds of people serve as volunteers for the Madison County Special Olympics, many give credit to Carl Erskine for founding and keeping the event alive. Below, Erskine (second from left) is seen with Special Olympics athletes at the Anderson Sertoma Club, while volunteer P.T. Morgan (far right) looks on. (Photograph by Harvey Riedel.)

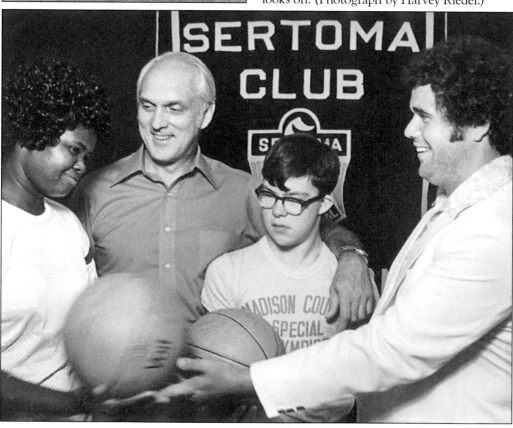

The Eagles Lodge All Eagle Band performed throughout Anderson during the mid-1900s. The band mostly appeared in parades and represented Federation of Eagles Lodge 174. The lodge is located at 1315 Meridian Street in downtown Anderson. (Courtesy of Louis Priddy.)

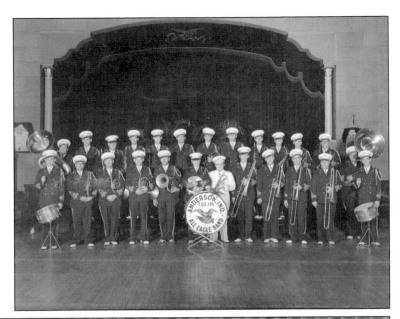

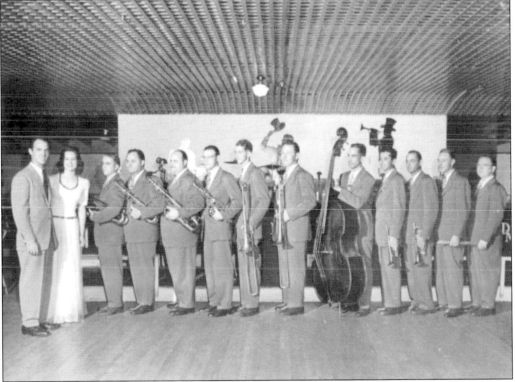

The Don Maines Band was one of Anderson's more popular bands during the jazz era of the 1930s and 1940s. Maines (left) and his band performed regularly at the Green Lantern on the west side of town, off of Eighth Street and Moss Island Road. During the Great Depression, the Green Lantern was the site of many marathon dances, where contestants danced the night away for prize money. Al Capone frequented the Green Lantern, as did other gangsters from that era. It was during this time that Anderson was known as "Little Chicago." (Courtesy of Louis Priddy.)

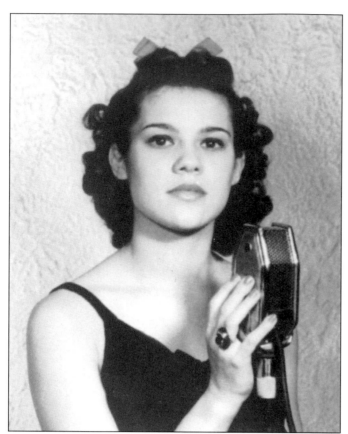

Betty Rhodes was known not only for her beauty, but for her smooth jazz voice. Rhodes sang for many bands during Anderson's jazz era. (Courtesy of Louis Priddy.)

Louis Priddy was an accomplished drummer who performed with different bands at Anderson's popular nightclubs. Priddy, now in his early 90s, resides in Anderson and is the author of the book *The Jazz Era of Anderson.* (Courtesy of Louis Priddy.)

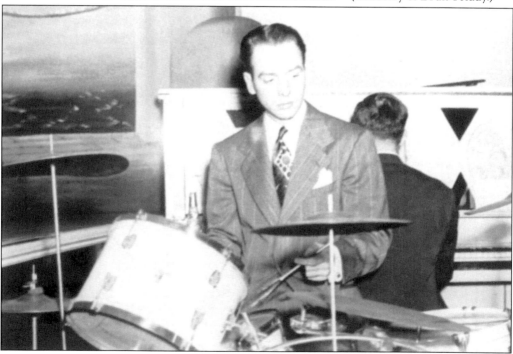

Legendary trumpeter and entertainer Louis Armstrong warms up in his dressing room prior to a performance at the Anderson High School Wigwam. Armstrong appeared in town on May 9, 1966, as part of the annual Anderson Redbud Festival. (Photograph by Harvey Riedel.)

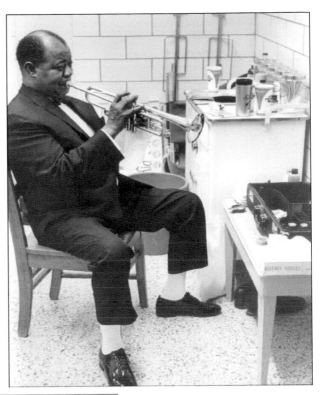

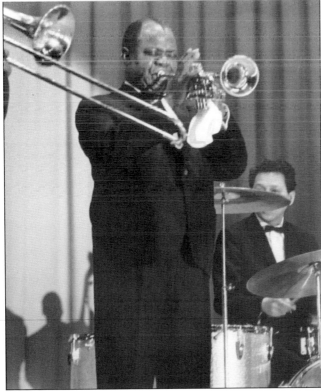

Louis Armstrong performs at the Anderson High School Wigwam. Throughout his illustrious career, Armstrong performed with some of the biggest names in show business and won a Grammy in 1964 for his song "Hello, Dolly." Armstrong, also known as "Satchmo," died in his sleep at the age of 69 in 1971. (Photograph by Harvey Riedel.)

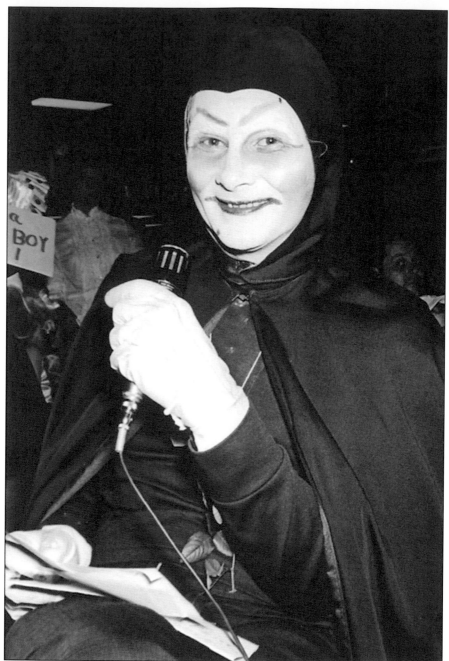

The Mounds Mall opened in the fall of 1965 on Scatterfield Road on the east side of town. To promote Anderson's new shopping mall, Indianapolis television celebrity Sammy Terry appeared there on Halloween night. Standing on a stage in the food court, Terry entertained the large audience with ghoulish stories before youngsters in costume paraded around the mall. Robert "Bob" Carter originated the role of Sammy Terry in 1962 and was host of *Nightmare Theatre* on Indianapolis television station WTTV. With his sidekick spider, George, Carter hosted the show through the 1970s. Carter, who had a huge cult following, passed away in 2013 at the age of 84. (Photograph by Harvey Riedel.)

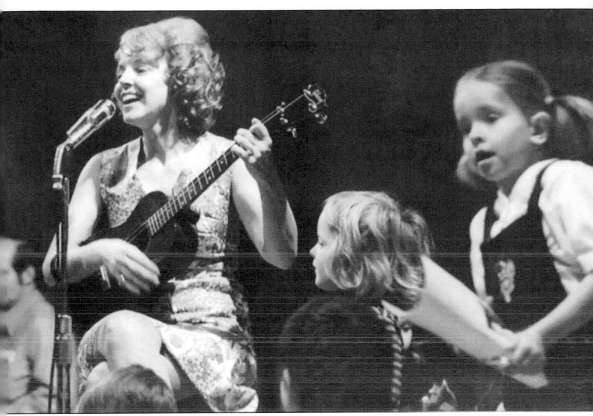

Janie Woods Hodges hosted the *Popeye and Janie Show* on WTTV channel 4 in Indianapolis. The popular afternoon children's program featured Hodges playing her ukulele and singing to members of the audience. *Popeye* cartoons were shown throughout the hour-long program. Here, Hodges is seen onstage during a guest appearance at the Mounds Mall. (Photograph by Harvey Riedel.)

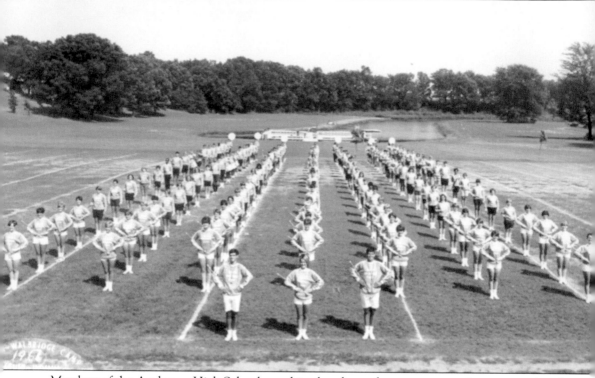

Members of the Anderson High School marching band pose for a group portrait at summer band camp in 1967. Band camp was held that year at Smith Walbridge Camp in Syracuse, Indiana. The Anderson High School band has won the Indiana State Fair Band Day competition six times, in 1957, 1958, 1959, 1985, 1986, and 2009. (Courtesy of If You Grew Up in Anderson.)

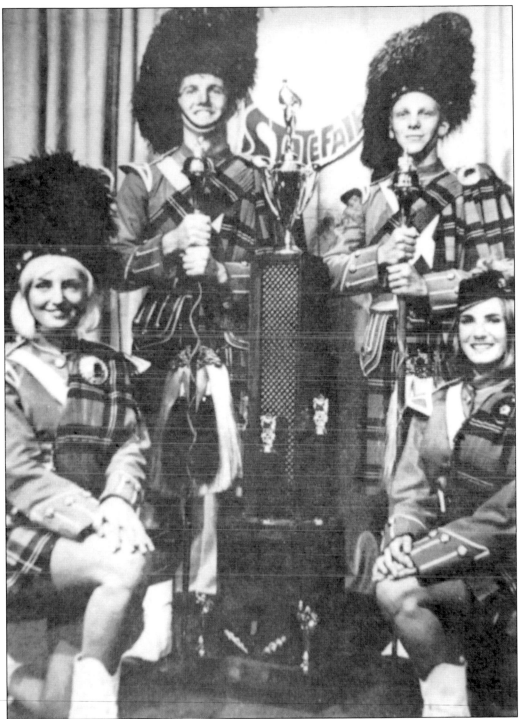

The Highland High School marching band was known not only for its legendary performances, but for its uniforms. Members of the Highland marching band wore kilts, and many played bagpipes during the show. Highland High School won Indiana State Fair Band Day in 1968, 1970, 1971, 2005, 2007, and 2009. (Courtesy of Highland High School.)

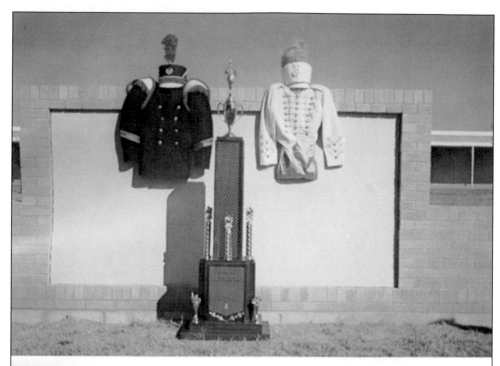

THE MADISON HEIGHTS STATE FAIR BAND TROPHY

There's Something About a Band

There's a nip in the air . . . a promise of the tang
that heralds the near approach of fall. Under the
Kleig lights the precision marching of a spirited
band stirs the standing fans to frenzy . . . Here is
poetry in motion . . . artistry in sound and sight . . .
disciplined perfection . . . the elegande of symmetry.

America and The National Anthem thrill with a mixture
of patriotism and school pride . . . For the moment
they are one . . . bringing a lump to the throat, a
blur to the eye . . .

A band . . . Young America on the march! . . . It's
something to see . . . It's something to glory in . . .

A band a group working in harmony without dissen-
tion . . . Team work . . . on the field, on the bench,
in the bleachers, among the cheerleaders . . . in the
classroom.

A band . . . students, faculty, administration . . .
giving tirelessly of their enthusiasm, their faith,
their hope, their loyalty . . . themselves . . .

Reward: a school which, whether winning or losing,
stands TOGETHER, shoulder to shoulder . . .

Mrs. Ruby A. Jones

Though it no longer exists as a structure, Madison Heights High School lives on in the memories of many. The school's marching band did not win as many Indiana State Fair Band Day titles as Highland and Anderson High, but it was crowned champion in 1963 and 1980. Madison Heights English teacher Ruby Jones captured the spirit of the marching band in her poem "There's Something About a Band." (Courtesy of Madison Heights High School.)

84

Four

AROUND TOWN

Frederick Brandenberg Sr. was born in Germany in 1775. Upon moving to the United States, he changed his last name to Bronnenberg. While operating a tanning business in Pennsylvania, Bronnenberg met and married Barbara Easter in 1806. The Bronnenbergs lived in Pennsylvania and Ohio before settling in Anderson with their eight children in 1819. Frederick Jr. (pictured) stayed on his father's farm until the mid-1800s, when he built his family a brick home using natural resources. Frederick Jr. and his family stayed at Mounds, expanding their tannery, farm, and mill, and fought to preserve the mounds from artifact hunters. The Bronnenberg home still stands at its original location in what is now Mounds State Park and is open for tours. (Courtesy of Mounds State Park.)

This early 1900s photograph shows a family enjoying a Sunday picnic at Mounds Park. The park remains a popular site for family picnics, camping, fishing, hiking, and weddings. (Courtesy of Mounds State Park.)

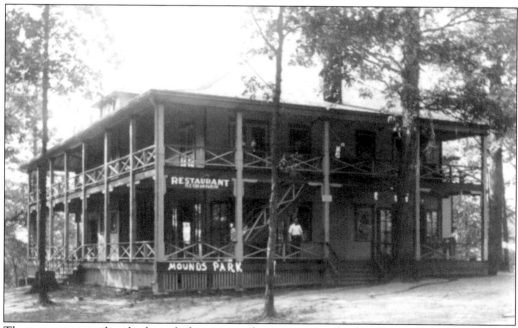

The two-story pavilion had a soda fountain and restaurant on the first floor, with a dance hall on the second floor. During the Roaring Twenties, many dances took place at the pavilion. (Courtesy of Mounds State Park.)

Customers stand outside Heiney's Polar Pantry, adjacent to Heiney's Produce Company, at 1215 East Twenty-third Street. Hobart Heiney operated the two businesses, which sold meat, produce, frozen foods, and ice cream. (Courtesy of the Madison County Historical Society.)

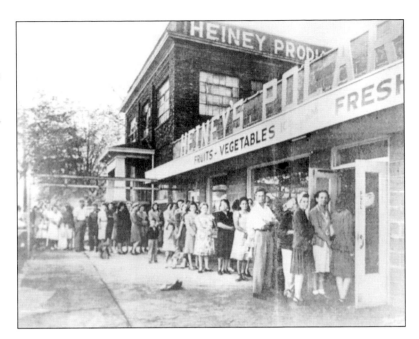

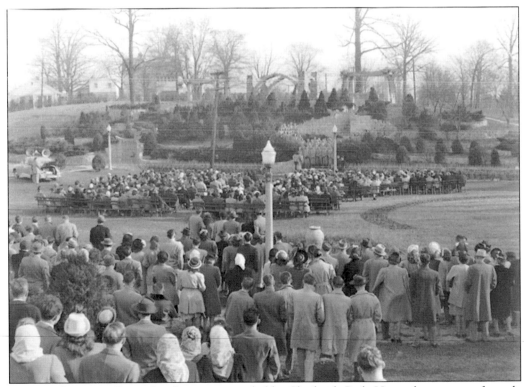

For several years, an Easter Sunday service was held at Shadyside Park. Here, a large group of people gather at the Japanese Gardens sometime in the 1940s. (Courtesy of Anderson Public Library.)

The Knights of Columbus is the world's largest Catholic fraternal organization. Founded in New Haven, Connecticut, in 1882 by Venerable Father Michael J. McGivney, the Knights of Columbus is named in honor of navigator Christopher Columbus. The Anderson Knights of Columbus dates back to the early 1900s and is one of the largest charitable organizations in the city. (Photograph by Norm Cook; courtesy of the Norm Cook family.)

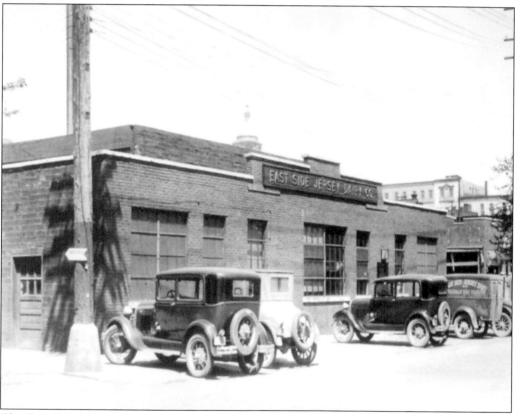

The East Side Jersey Dairy company office was located at 1009 Central Avenue, just east of the downtown area. In this 1930 photograph of the dairy company office, the dome of the Madison County Courthouse is visible in the background. In 1942, East Side Jersey Dairy moved to 722 Broadway and changed its name to Best-Ever Dairy. (Photograph by Norm Cook; courtesy of the Norm Cook family.)

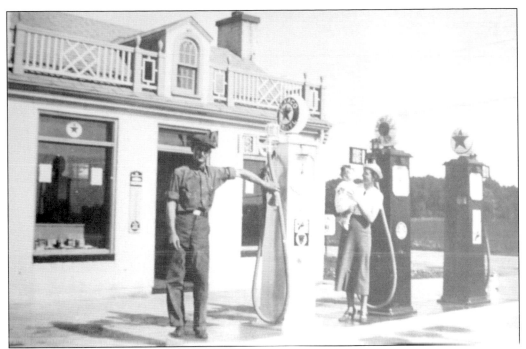

In the spring of 1936, H.P. Nuce opened Nuce Texaco at the corner of Thirty-eighth and Main Streets. In 1952, his son Raymond joined the firm and later gave ownership to his son Mike. Nuce Texaco, now known as Phillip's 66, still stands at its original location and remains a thriving business. (Courtesy of Mike Nuce.)

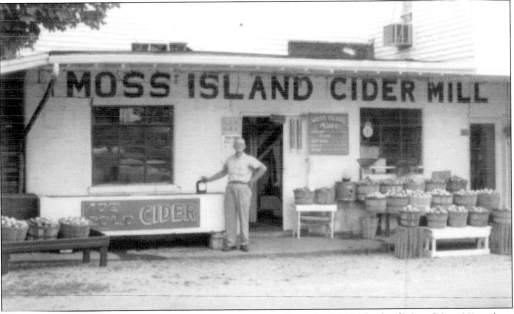

Joe Mailman stands outside the Moss Island Cider Mill in the 3000 block of Moss Island Road on the west side of town. The Moss Island Cider Mill ran adjacent to the Old Moss Island Mill, also owned by Mailman. At Hoosierland Orchard, another popular Anderson-area business, customers could purchase cider and apples during the fall. (Courtesy of If You Grew Up in Anderson.)

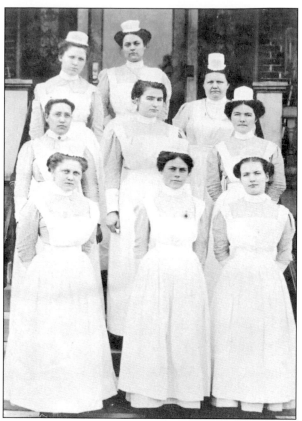

Members of the 1911 graduating class of the School of Nursing at Saint John's Hospital pose for a group portrait. The school was founded under the administration of Sister Benita. (Courtesy of Saint Vincent Anderson Regional Hospital.)

Nurses enjoy a game of softball outside the Raphael Hall nurse's residence in the spring of 1937. (Courtesy of Saint Vincent Anderson Regional Hospital.)

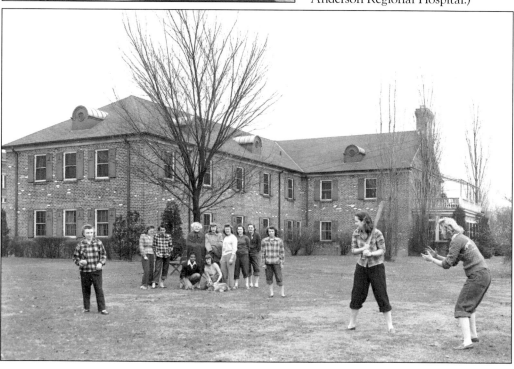

A crowd gathers on the grounds of Saint John's Hospital to celebrate the 1944 opening of the medical facility's newly built North Wing. (Courtesy of Saint Vincent Anderson Regional Hospital.)

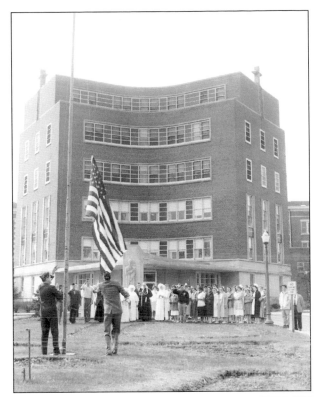

Graduates of the 1950 Saint John's nurse's class attend a reception after the ceremony. (Courtesy of Saint Vincent Anderson Regional Hospital.)

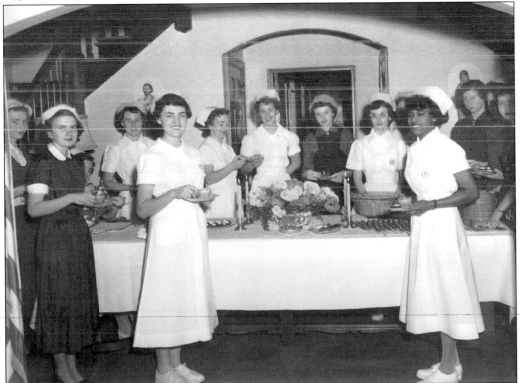

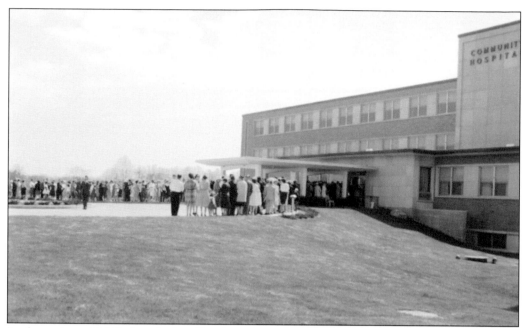

In the spring of 1962, hundreds of local residents attended an open house at the newly built Community Hospital of Anderson. The new hospital, on North Madison Avenue, was made possible through $3.5 million in contributions from Anderson residents and businesses. The 142-bed facility was open to patients on May 30, 1962, with the first surgery performed on June 1 of that same year. In May 1967, two additional floors were added to the hospital at a cost of $1 million. Today, Community Hospital provides 24-hour emergency care. A Diabetes Care Center provides education and programs, and the da Vinci surgical system provides surgeons with greater precision, control, and access to hard-to-reach areas of the body. (Courtesy of Community Hospital Anderson.)

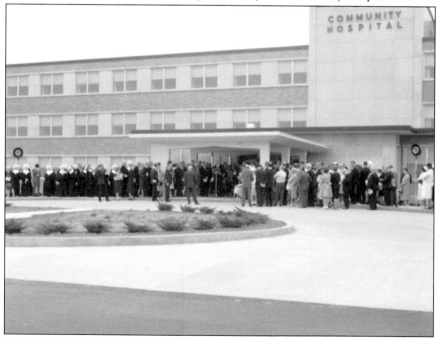

In 1947, Bud Contos opened his corner grocery store on Pearl Street east of downtown. The young entrepreneur later became president of Pay Less Supermarket, opening multiple stores in Anderson and Lafayette. Tragically, Contos passed away in 1961 while in his early 40s. Contos's son Larry took over operations and helped build one of Anderson's most successful and long-lasting family-owned businesses. (Courtesy of Everett Muterspaugh.)

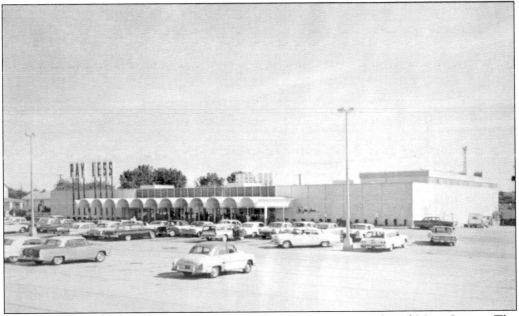

Pay Less Supermarket is seen here in the early 1960s at Twenty-ninth and Main Streets. The supermarket sold dry foods, fresh meats and produce, dairy products, bakery goods, and household items. In the years that followed, Pay Less added stores at Seventh Street and the 109 Bypass, Nichol Avenue, North Broadway, and the Applewood Center. The Pay Less Supermarket at Twenty-ninth and Main Streets has been at the same location for over 50 years. (Courtesy of Everett Muterspaugh.)

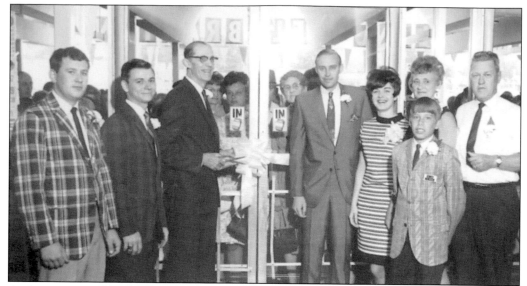

Anderson mayor Frank Ellis (third from left) cuts the ribbon at the newly remodeled Pay Less Supermarket at Twenty-ninth and Main Streets in the summer of 1967. Those attending the ceremony included, from left to right, area manager Joe Garrett, store manager Everett Muterspaugh, Mayor Ellis, Pay Less Supermarket president Larry Contos, Lou Ann Contos, Eloise Contos, Kim Contos, and bakery manager Newton Howard. (Courtesy of Everett Muterspaugh.)

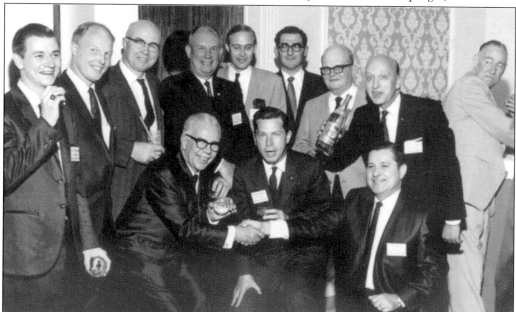

In 1967, a group of Anderson grocery store personnel and prominent business owners met for dinner and drinks. Attending the get-together were, in unknown order, Everett Muterspaugh (Pay Less Supermarket), Larry Contos (Pay Less Supermarket), Carl Cotton (Dietzen's Bakery), Charles Laughlin (vice president, Anderson newspapers), Ed Scezny (Scezny's Market), Doug and Plez Matthews (Matthews Supermarket), Dick Maier (Maier's Market), Earl Benzenbouer (Bell's Market), Bob Mace (Mace's Market), and Leonard Yancey (Yancey's Market). (Courtesy of Everett Muterspaugh.)

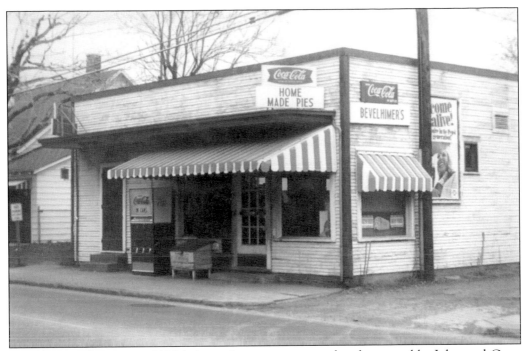

Bevelhimer's Grocery, at 214 Madison Avenue, was owned and operated by John and Gene Bevelhimer. The family-owned grocery was known for its fresh-cut meats and homemade pies. Many students who walked to Anderson High School in the morning would stop by Bevelhimer's for a slice of pie. This photograph of the store was taken in 1965 and illustrates the era of the mom-and-pop corner stores in Anderson. (Courtesy of If You Grew Up in Anderson.)

John Bevelhimer cuts into a ham at Bevelhimer's Grocery. The gregarious owner was known to sing "Candy Kisses" to his regular customers. (Courtesy of If You Grew Up in Anderson.)

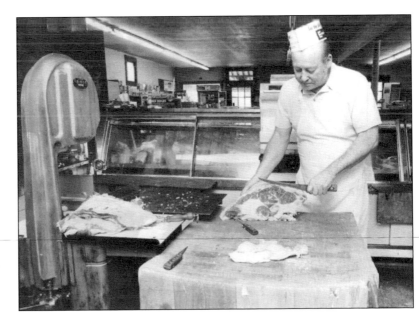

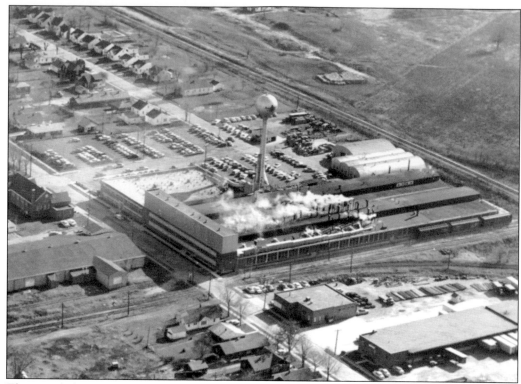

This aerial photograph of the Anaconda Wire & Cable plant shows the factory in full operation at 505 East Thirty-first Street. Anaconda produced magnetic wire and was one of many factories in Anderson that provided employment for thousands of the city's residents. (Photograph by Norm Cook; courtesy of the Norm Cook family.)

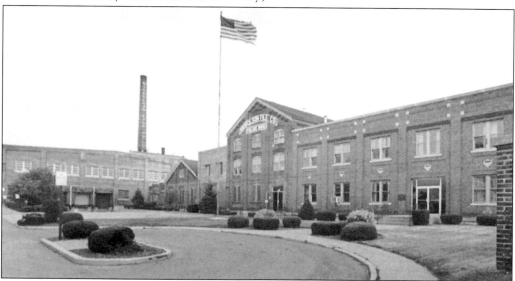

Nicholson File Company was the world's largest producer of files. In 1900, the factory was updated, making it possible to produce 5,000 files per day. Located at Thirty-fourth and East Lynn Streets, Nicholson File ceased operation on August 31, 1978. (Courtesy of If You Grew Up in Anderson.)

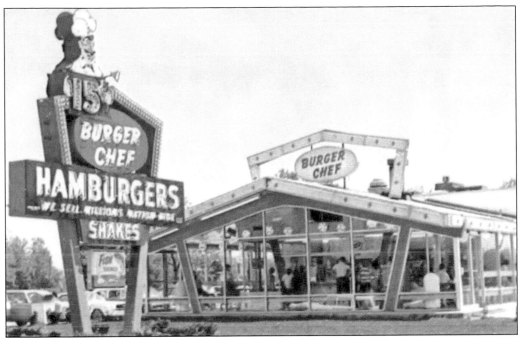

During the 1960s, several fast-food drive-in restaurants opened in Anderson, including McDonald's, Henry's, Burger Man, and Burger Chef. Burger Chef had establishments in Anderson on East Fifty-third Street and on Nichol Avenue. (Courtesy of If You Grew Up in Anderson.)

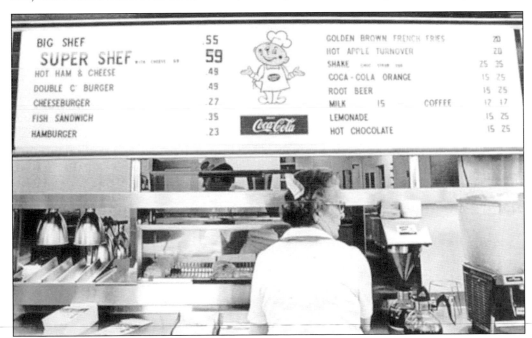

A waitress stands behind the counter at one of Anderson's Burger Chef drive-in restaurants. The Big Shef and Super Shef were two of the more popular sandwiches on the menu. During the 1960s and 1970s, it was not uncommon to find Burger Chef Birdhouses along highways throughout Indiana. (Courtesy of If You Grew Up in Anderson.)

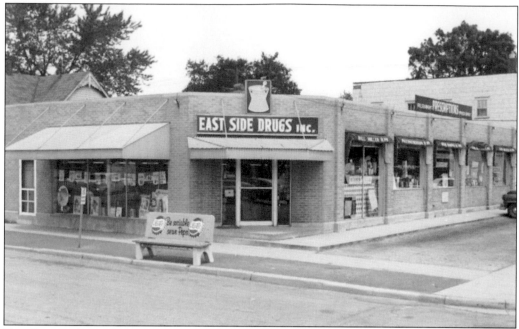

Tom Dearing began his career as a pharmacist at Phillips Drugs in 1949. In 1951, Dearing opened Tom Dearing East Side Drugs at 702 East Eighth Street, in the same building that had housed Philips Drugs. Dearing passed away in 1975. His son Wilbur took over the pharmacy, which stayed in business until 1995. (Courtesy of If You Grew Up in Anderson.)

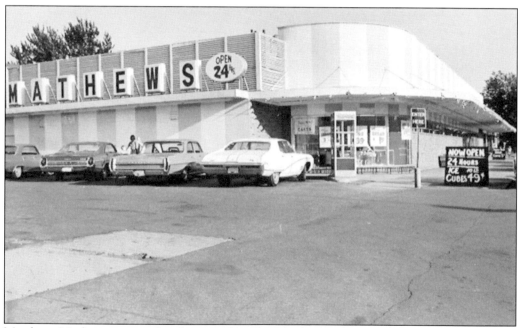

Matthews Market was owned and operated by Plez Matthews, who presided over several stores in the Anderson area. This is the Matthews Market at Nineteenth and Meridian Streets, just south of downtown. Other locations were at Thirty-first Street and Columbus Avenue, and on North Broadway. (Courtesy of If You Grew Up in Anderson.)

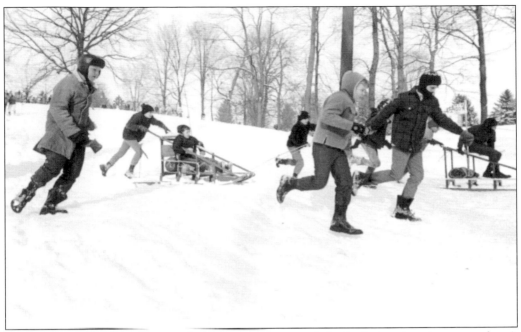

Shadyside Park has long been a place where youngsters sled-ride during the winter months. A steep hill at the south end of the park is not only enjoyable, but can be a daring feat for the adventurous. (Photograph by Harvey Riedel.)

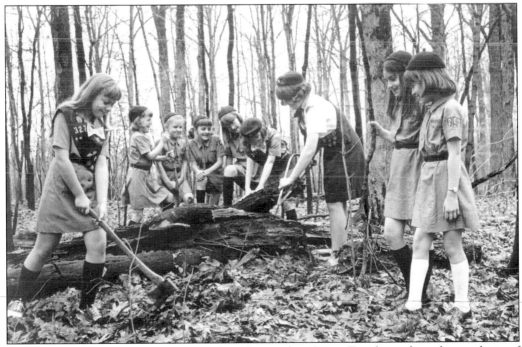

Girl Scouts from troops 327 and 209 chop firewood at Camp Tanglewood on the outskirts of town. (Photograph by Harvey Riedel.)

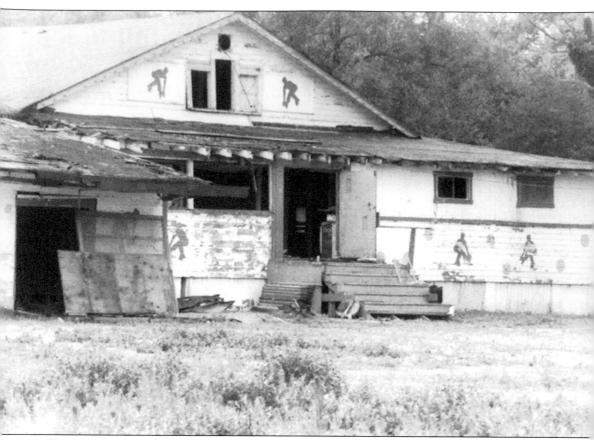

For over 40 years, Skate-Mor provided hours of entertainment for the old and young alike. The skating rink, near West Eighth Street and Moss Island Road, closed its doors in 1980. The building was the original site of the Green Lantern nightclub and later Eyers Skating Rink. The dilapidated building was razed after it closed for business. (Courtesy of If You Grew Up in Anderson.)

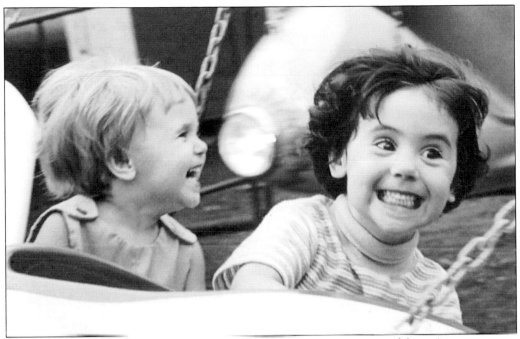

From the 1940s through the 1970s, the Anderson Free Fair was the most celebrated summer event in the city. Held every year at Athletic Park to coincide with the Fourth of July, the fair attracted thousands from Anderson and Madison County. The fair had something for everyone, including rides, an arcade, live entertainment, food and drink, and games on the Magic Midway. On Kid's Day, held on Wednesday afternoon, youngsters had the entire Free Fair grounds to themselves. This photograph of two young girls on a ride captures the essence of the Anderson Free Fair and brings back memories of days gone by. (Photograph by Harvey Riedel.)

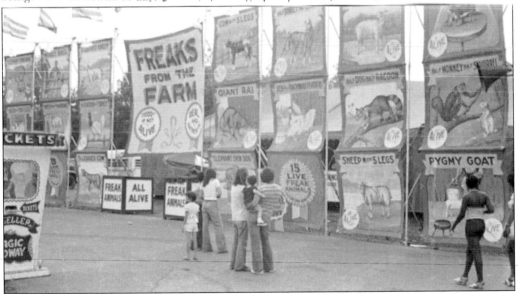

Fairgoers ponder entering the Freaks from the Farm sideshow at the 1973 Anderson Free Fair. The hand-painted signs were more interesting than the freak show itself, which nevertheless remained one of the biggest attractions at the fair. (Photograph by Harvey Riedel.)

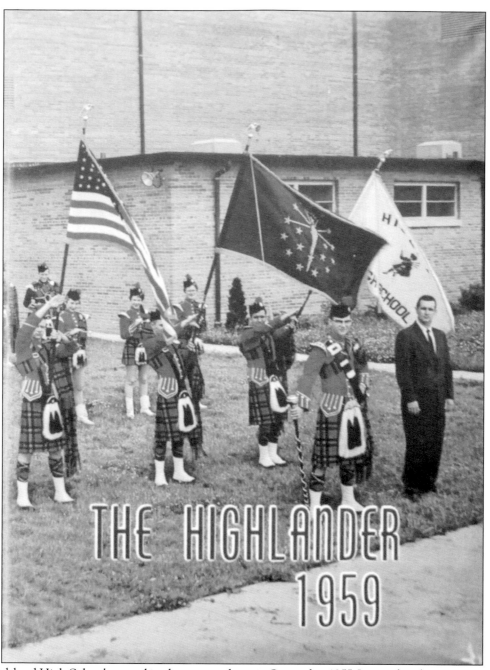

THE HIGHLANDER
1959

Highland High School opened its doors to students in September 1955. Located at the intersection of Cross Street and Rangeline Road, the school was built to help accommodate the growing need for educational institutions in the Anderson area. In 1971, Highland High School became a member of the Anderson Community School Corporation. The Highland mascot and members of the marching band dressed in traditional Scottish kilts. The school newspaper was *The Tartan*, and the school song was "Scotland the Brave." In 2010, Highland High School consolidated with Anderson High School, and the old high school building became Highland Middle School. (Courtesy Highland High School.)

1956 Indian

In 1898, the first Anderson High School building was erected at Twelfth and Lincoln Streets. Prior to this, high school students attended class at the Opera House in downtown Anderson and on the third floor of the Lincoln School, sharing space with grammar-school students. In 1958, a fire destroyed the Anderson High School gymnasium, leading to the construction of the Wigwam in 1961. Through the years, Anderson High School students have excelled at academics and athletics. The title of Indiana Mr. Basketball has been awarded to four different Anderson High players, and the school has won three state basketball championships. The school colors have long been red and green, with the Indian as the mascot. Anderson High School is the only public high school that remains in the city after the closing of Madison Heights High School and Highland High School. (Courtesy of Anderson High School.)

The Treasure Chest

Madison Heights High School opened in 1956 at 4610 South Madison Avenue. The school fight song was "Wave the Banner," and the school mascot was the pirate or buccaneer. The *Jolly Roger* served as the school newspaper. The school motto was "Walk Tall, Be Proud, You Are a Pirate." Through the years, Madison Heights High School won several academic and athletic awards, including the 1968 Indiana high school state golf tournament. In 1997, Madison Heights High School closed and was renamed Anderson High School. On the last day of school that year, a solemn ceremony took place in the gymnasium that was attended by hundreds of past Madison Heights graduates. During the ceremony, longtime Madison Heights government teacher William Riffe covered the Pirate emblem at center court with a white sheet, bringing a sense of closure to the tearful crowd. (Courtesy of Madison Heights High School.)

Five

POSTCARDS,
ADVERTISEMENTS,
AND DOCUMENTS

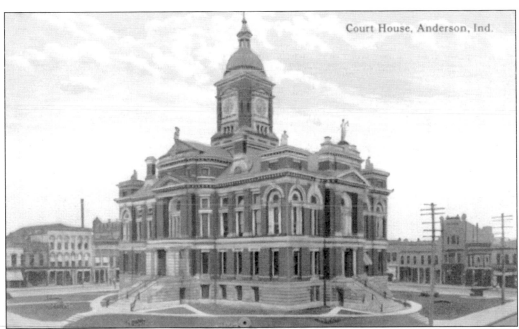

The Madison County Courthouse was constructed in 1882 and served Anderson and Madison County residents for over 90 years. On Ninth Street between Meridian and Main Streets, the courthouse was the center of the public square. Despite much protest from Anderson residents, the beautifully structured courthouse was demolished in 1972. Today, the Madison County Government Center stands at this site. (Courtesy of the Anderson Public Library.)

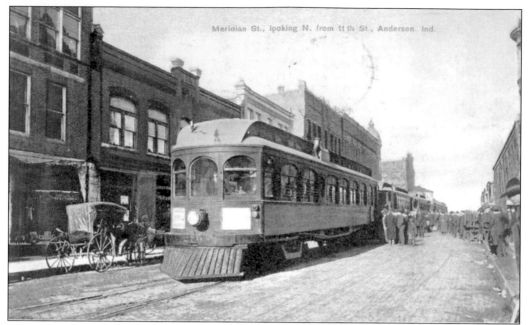

The interurban was a means of transportation for many of Anderson's residents in the early 1900s. In this postcard, passengers get on board the interurban at Eleventh and Meridian Streets. (Courtesy of the Anderson Downtown Neighbors Association.)

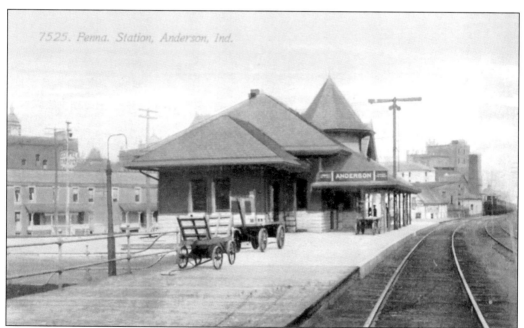

The Pennsylvania Railroad Station handled freight and passenger trains into the 1960s. The station was at Ninth and Fletcher Streets. When the building was no longer used as a railroad station, it became the site of a discotheque. The building was damaged by fire in 1975 and later demolished. This postcard shows the Pennsylvania Railroad Station as it looked in 1913. (Courtesy of the Anderson Downtown Neighbors Association.)

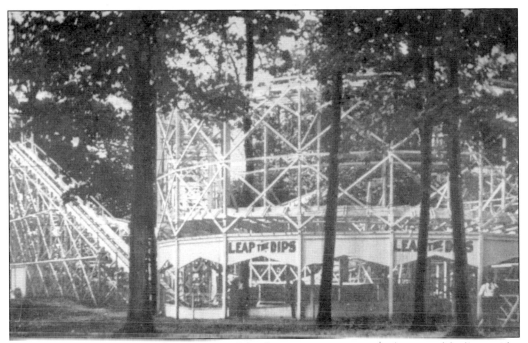

Mounds Park was known as having one of the finest amusement parks in central Indiana. The Leaps and Dips rollercoaster was one of the park's biggest attractions. Balloon rides, concession stands, and boating were also offered to park visitors. (Courtesy of Mounds State Park.)

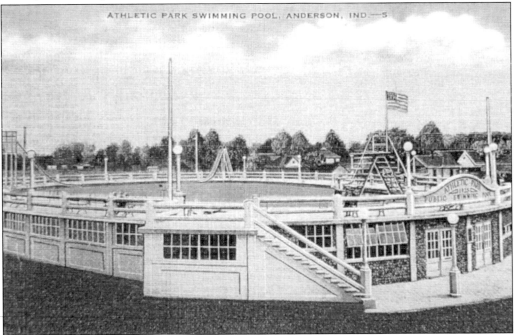

The Athletic Park swimming pool is located on the grounds of Athletic Park on East Eighth Street in Park Place. Built in 1925, the swimming pool has a stone exterior and was one of the more popular family attractions in the area for many years. (Courtesy of the Madison County Historical Society.)

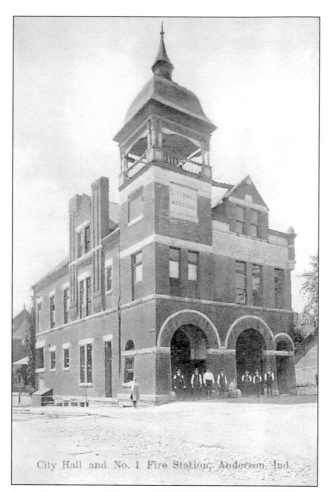

Firefighters and their canine companion stand outside City Hall and Fire Station No. 1 around 1910. The mayor and city officials maintained the second floor of the building, while the fire station operated from the ground level. City Hall and Fire Station No. 1 was built in 1886 and stood on Eighth Street between Central Avenue and Main Street. (Courtesy of the Anderson Public Library.)

City Hall and No. 1 Fire Station, Anderson, Ind.

The Anderson Old Peoples' Home was built by the Gospel Trumpet Company to give its workers a place to live after retirement. (Courtesy of the Madison County Historical Society.)

The first Anderson High School was located at the corner of Twelfth and Lincoln Streets. The building was erected in 1890 at a cost of $35,000. When the new Anderson High School was built in 1910, this structure became the site of Central Junior High School. (Courtesy of the Madison County Historical Society.)

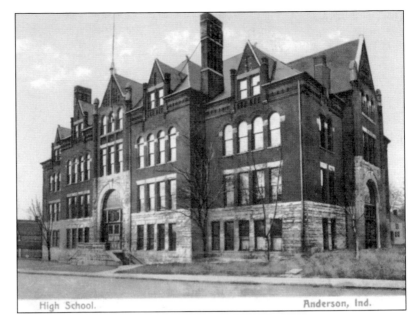

High School. Anderson, Ind.

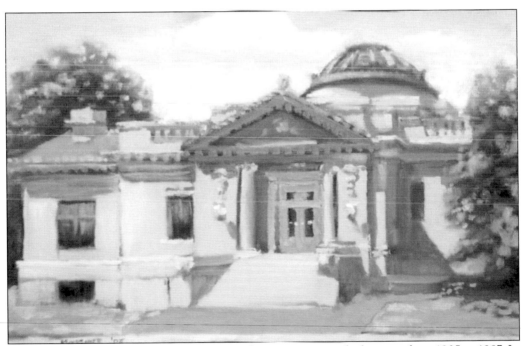

The Anderson Carnegie Public Library served as a cornerstone for learning from 1905 to 1987. In 1987, the library relocated to its current site at Eleventh and Main Streets. The Anderson Center for the Arts now operates from within the Carnegie building at 32 West Tenth Street. This postcard is from a painting by Anderson artist Patrick Kluesner. (Courtesy of Patrick Kluesner.)

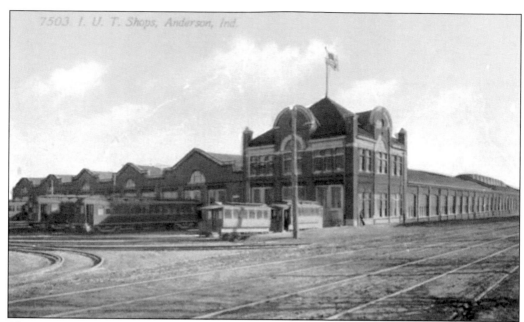

The Union Traction Company of Indiana grew out of an interurban line between Anderson and Alexandria. The street railroad system served the central third of Indiana and maintained over 400 miles of track. The company office was in Anderson, as was the repair and technical facility. (Courtesy of the Anderson Public Library.)

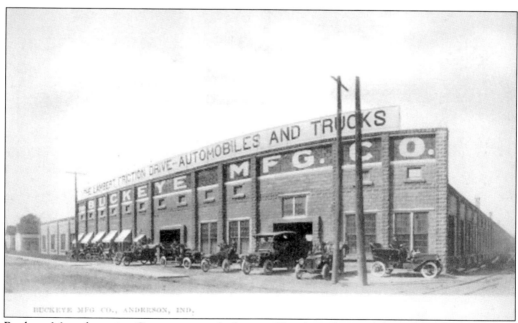

Buckeye Manufacturing Company was the home of Lambert Automobile and Trucks. Originally located at Third and Sycamore Streets, Lambert grew in size and built a larger factory on Columbus Avenue. (Courtesy of Perry Knox.)

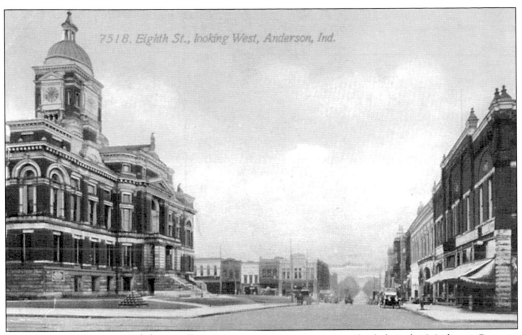

This early 1900s postcard depicts Eighth Street looking west. To the left is the Madison County Courthouse. Cannonballs from the Civil War are displayed on the courthouse lawn. (Courtesy of the Madison County Historical Society.)

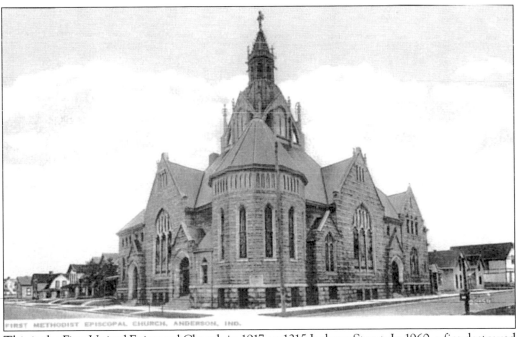

This is the First United Episcopal Church in 1917, at 1215 Jackson Street. In 1960, a fire destroyed the church. Today, the First United Methodist Church stands at this site. (Courtesy of the Madison County Historical Society.)

The Citizens Bank Building was located at 15 West Eleventh Street in downtown Anderson. This postcard shows the interior of the bank, with teller windows on the left. At one time, Citizens Bank had several branches throughout the city, including one at Thirty-seventh and Main Streets. The bank was founded in 1855 by Neil C. McCullough and Chief Justice Bryan K. Elliot of the Indiana Supreme Court. (Courtesy of the Madison County Historical Society.)

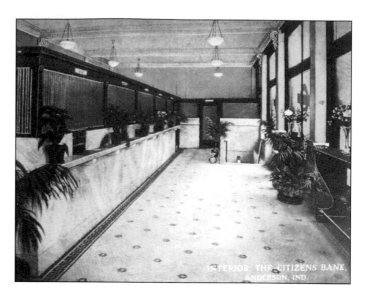

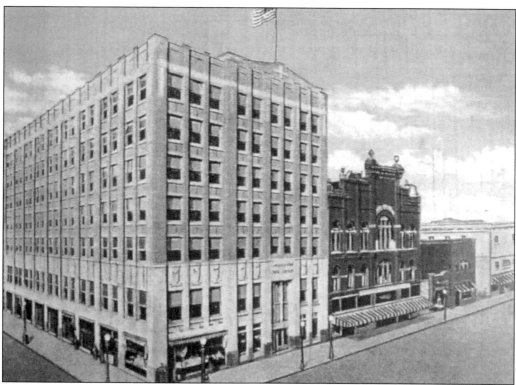

Anderson Bank opened this building at Tenth and Meridian Streets in 1928. It was the only bank in the city to survive the Great Depression without closing. In the early 1990s, Anderson Bank merged with National City Bank. Today, the business is known as PNC Bank. (Courtesy of the Madison County Historical Society.)

Shown here is downtown Anderson as it looked during the Great Depression. Cars line Meridian Street, where the Paramount and Riviera Theatres showed the latest Hollywood movies. (Courtesy of the Madison County Historical Society.)

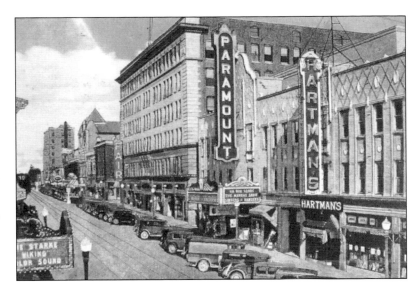

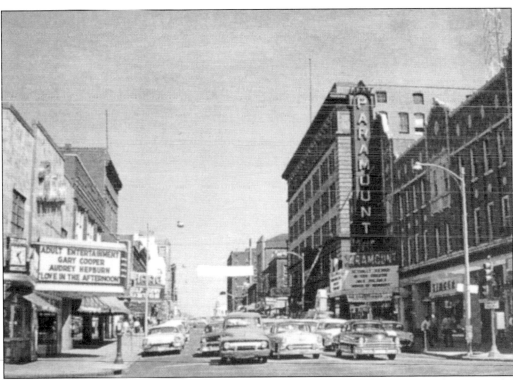

This rare postcard features an actual photograph of Meridian Street, taken in 1957. Showing at the Riviera Theatre is *Love in the Afternoon*. The movie starred Audrey Hepburn and Gary Cooper. Just south of the Riviera is Hagg Drugs. Across from the Riviera are the Paramount Theatre and the Union Building. (Courtesy of the Madison County Historical Society.)

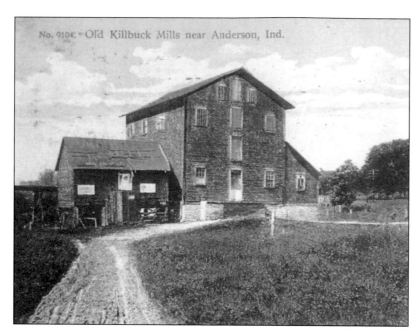

No. 9104. Old Killbuck Mills near Anderson, Ind.

Killbuck Mills was on Grand Avenue, west of Broadway. Built in 1862, Killbuck Mills provided flour and lumber for its Anderson-area customers. The facility ceased operation in the early 1900s and was torn down after World War II. (Courtesy of the Madison County Historical Society.)

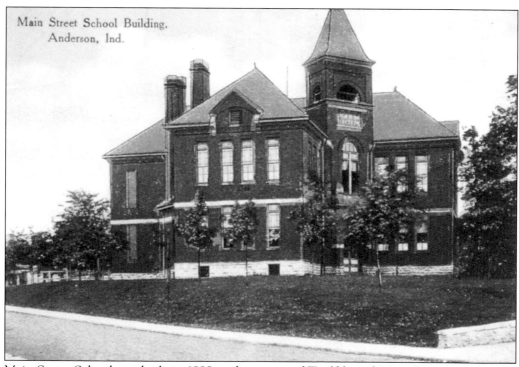

Main Street School Building, Anderson, Ind.

Main Street School was built in 1888 at the corner of Twelfth and Main Streets. Today, the Anderson Public Library is located on the grounds where the school once stood. (Courtesy of the Madison County Historical Society.)

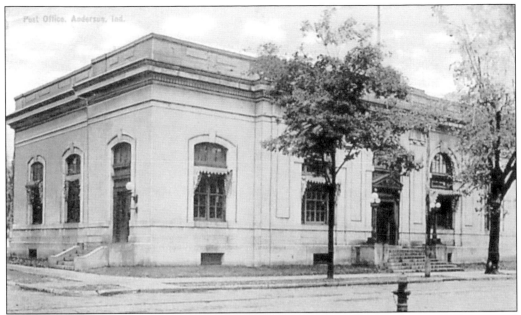

This postcard shows the Anderson Post Office at Eleventh and Jackson Streets in 1915. A second story was added in 1929 to house more federal and government offices. (Courtesy of the Madison County Historical Society.)

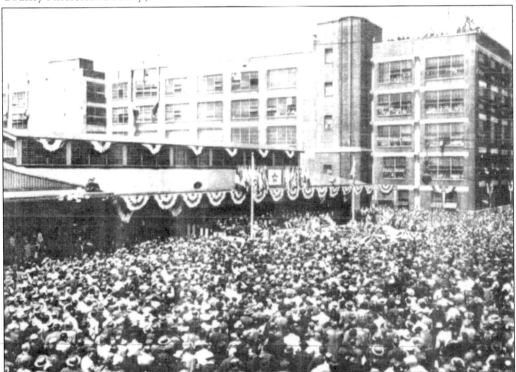

Over 10,000 Delco-Remy employees gather outside the automobile plant on Columbus Avenue to view the "E" flag. The company received the flag for its contributions to the war effort. This event took place on May 4, 1943. (Courtesy of the Madison County Historical Society.)

INDIANA'S LARGEST & FINEST SUBURBAN RESTAURANT

FIVE AIR-CONDITIONED DINING ROOMS

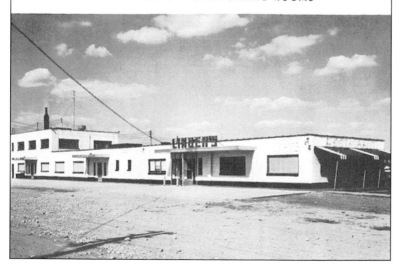

Linder's On the Point was a popular restaurant and bar at Fifty-third Street and State Road 67, on the south side of town. Linder's stood on a piece of ground where the two roads intersected, giving the establishment its name. The bar and restaurant were on the ground floor, with the second floor reserved for parties and weddings. There was a time when Linder's had carhops, as did many Anderson-area restaurants. Linder's On the Point closed in the early 2000s, and the building was later razed. (Courtesy of If You Grew Up in Anderson.)

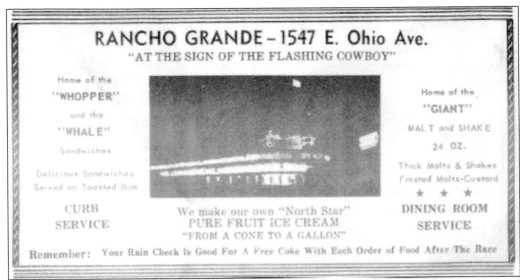

The Rancho Grande, at 1547 East Ohio Avenue, offered curb or dining-room service to patrons. Long before super-sizing became popular, the Rancho Grande had the Whale and Whopper sandwiches and giant milkshakes on the menu. Customers who purchased soft drinks at the Rancho Grande received a pretzel placed around the straw by the waitress. (Courtesy of If You Grew Up in Anderson.)

The Pelican at Lloyd's Landing was a bar and eatery on South Main Street. From the late 1970s through the mid-1980s, the Pelican was a popular place for friends to gather for drinks after work and for families to enjoy dinner. In the summer, patrons enjoyed sitting on the deck that overlooked a pond. Live entertainment and a jukebox were available to those who enjoyed listening to music while drinking a cold beer. (Courtesy of If You Grew Up in Anderson.)

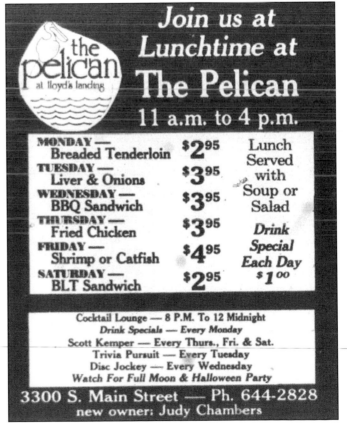

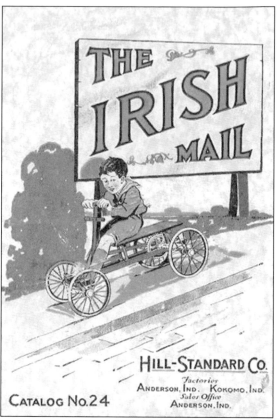

Hugh Hill invented the Irish Mail, a self-propelled riding toy for children. The Irish Mail was produced at the Hill Tool Company, which later became the Hill Standard Company. Hill Standard manufactured lightweight metal wheels and became one of the world's largest producers of the item. The company, at Twenty-Second Street and the Big Four Railroad, employed over 100. (Courtesy of If You Grew Up in Anderson.)

The DeTamble Automobile Company operated in Anderson from 1908 through 1912. The factory was located at 1200 East Thirty-second Street and employed over 600 workers. It was owned and operated by Edward S. DeTamble. (Courtesy of If You Grew Up in Anderson.)

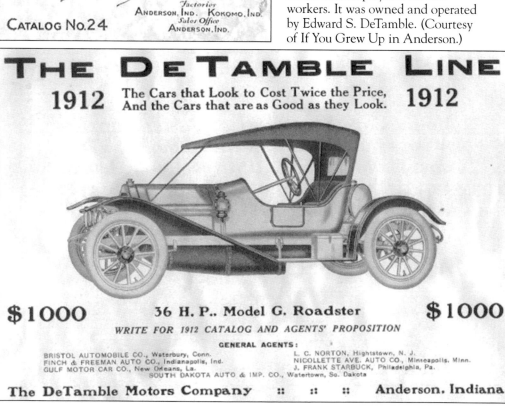

118

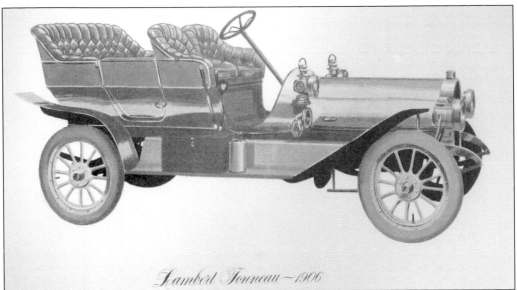

Lambert Tonneau – 1906

In 1906, John William Lambert produced the first automobile that bore his name. The Buckeye Manufacturing Company produced the Lambert automobile through 1917. From 1907 to 1910, the company built an average of 2,000 cars per year. (Courtesy of If You Grew Up in Anderson.)

LOOK TO HOWE FOR THE NEWEST IN FIRE APPARATUS

Features essential to efficient fire fighting are built into Howe Fire Trucks. Here are "firemen's fire trucks," the result of four generations of manufacturing experience. Equipment is Underwriter Approved. Truck shown above is mounted on Howe DEFENDER custom-built chassis with 750 Gallons Per Minute capacity pump, special semi-cab, and rear-mounted reel . . . Write for free literature. Ask to have a Howe representative call on you.

INTERIOR OF A HOWE BOOSTER TANK

SOME OUTSTANDING FEATURES YOU GET WITH HOWE!

- **Completely removable top** on Howe Booster Tank gives access for cleaning. Tank is rust-treated with special U. S. Navy developed 3-coat Vinyl-Resin lacquer. Automatic water level gauge.
- **Automatic pump prime indicator** to eliminate danger of premature shifting and loss of prime.
- **Quick opening valve controls,** fingertip, ball type, throughout. Operate under any pressure.
- **All instruments and controls** in pump panel collared with removable stainless steel plate for easy access to pump's working parts.
- **Special construction non-slip** running boards. (Not ordinary tread plate.)

HOWE

MEMBER OF FAM FIRE APPARATUS MANUFACTURERS ASSOCIATION

FIRE APPARATUS COMPANY

"dependable fire apparatus since 1872"

Dept. FE3 1405 West 22nd St., Anderson, Indiana

BELOW: One Day's Deliveries for Satisfied Howe Customers All Over United States.

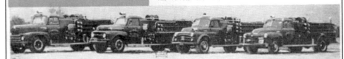

The Howe Fire Apparatus Company manufactured fire trucks and equipment for over 60 years. In 1966, Howe Fire closed its doors in Anderson and relocated to Roanoke, Virginia. The company was located at 1405 West Twenty-second Street. (Courtesy of If You Grew Up in Anderson.)

CAR AHEAD!

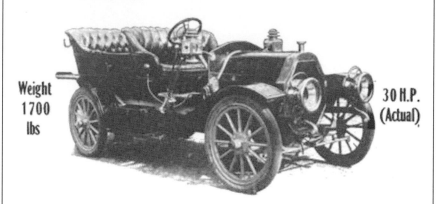

Weight
1700
lbs

30 H.P.
(Actual)

RIDER-LEWIS "FOUR"

The Biggest Little Car Ever Built

¶ In design, appearance and ability, the Rider-Lewis IV easily heads the list of popular priced cars.

―――― FEATURES: ――――

Four Cylinders
Valves in the Head
Magneto Ignition
Thermo-Syphon Cooling
32" x 3½" Tires

Flexible Motor Supports
Rear Axle Gear Set, 3 Speeds
Straight Line Drive
Light Weight
100" Wheel Base

―Simplicity the Very Keynote of the Design―

WE ALSO MANUFACTURE THE EXCELLENT SIX

(The Most Luxurious of Cars), Price. $2500

CATALOG ON REQUEST. AGENTS GET OUR PROPOSITION

Price, $1000 The Rider-Lewis Motor Car Co.
Muncie and Anderson, Indiana

The Rider-Lewis Motor Car Company operated in Anderson from 1909 to 1911. By June 1910, the 175 employees were producing four-cylinder cars at a rate of 30 to 40 per week. A year later, the company fell on financial hard times and ceased operation at the Anderson plant. (Courtesy of If You Grew Up in Anderson.)

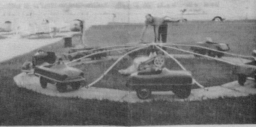

The *Delco Sparks* newspaper announces a mortgage-burning ceremony for June 30, 1963. The guest speaker at the ceremony was United Auto Workers president Walter Reuther. UAW Local 662 relocated its headquarters to a new building on Scatterfield Road. (Courtesy of the UAW Local 663.)

On weekday mornings in the 1960s, children could be heard throughout Anderson yelling, "It's the Omar Man!" The Omar Man delivered bakery items, potato chips, and snacks to homes in the Omar truck. The Omar headquarters was on State Road 67 South, near McDonald's Furniture Store. (Courtesy of If You Grew Up in Anderson.)

The Giant Store announces its grand opening in this early 1960s advertisement. The newly opened discount store lived up to its name with its warehouse-sized facility. The Giant Store sold clothing, records, and sporting goods, and had an arcade with a miniature bowling alley. (Courtesy of If You Grew Up in Anderson.)

Red Barn Chicken was located at the T-Way Plaza on Scatterfield Road, across from the Mounds Mall. (Courtesy of If You Grew Up in Anderson.)

Frisch's Big Boy opened in downtown Anderson in the early 1960s at the corner of Ninth and Meridian Streets. The most popular item on the menu was the double-deck Big Boy sandwich, complete with the famous Big Boy tartar sauce. Frisch's also had a drive-in restaurant on North Broadway that remains in business today. The downtown location closed in the late 1990s. (Courtesy of If You Grew Up in Anderson.)

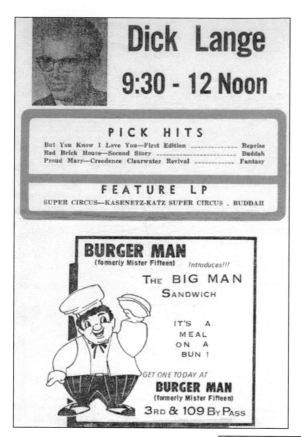

Local disc jockey Dick Lange was featured on this advertisement for the Burger Man restaurant, on Third Street and the 109 Bypass. Burger Man offered the Big Man sandwich, which rivaled the Frisch's Big Boy. Burger Man, formerly called Mister Fifteen, went out of business in the 1970s. (Courtesy of If You Grew Up in Anderson.)

McDonald's opened its first of several Anderson drive-in restaurants in 1960. Located at Fourteenth and Jackson Streets, McDonald's had a 15¢ hamburger on its menu. Nino the Clown made balloons for children and gave orchids to ladies at the grand opening. (Courtesy of If You Grew Up in Anderson.)

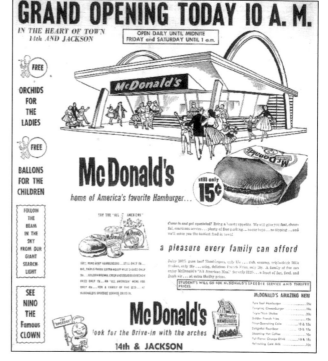

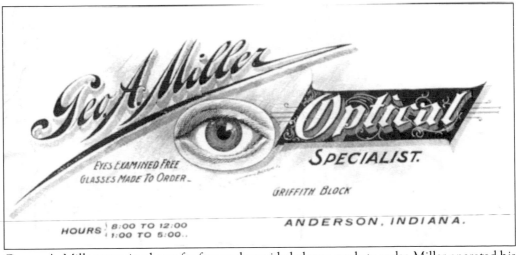

EUGENE T. BRICKLEY

Drugs, Wall Paper and Cameras

WE DEVELOP AND PRINT

Corner 9th and Meridian Streets ANDERSON, IND.

M _Dr. J.M. Jones_ OCT 11 1920

1	Developing	15
1	Prints Each 6	36
	Total	5 1¢

This receipt from Eugene T. Brickley Drugs, Wallpaper, and Camera store is made out to Dr. T.M. Jones. Dated October 11, 1920, it shows that Dr. Jones was charged 15¢ for film developing and 6¢ per print. The business was located at Ninth and Meridian Streets. (Courtesy of the Anderson Downtown Neighbors Association.)

George A. Miller examined eyes for free and provided glasses made to order. Miller operated his optometry business in the Griffith Block of downtown Anderson. (Courtesy of the Anderson Downtown Neighbors Association.)

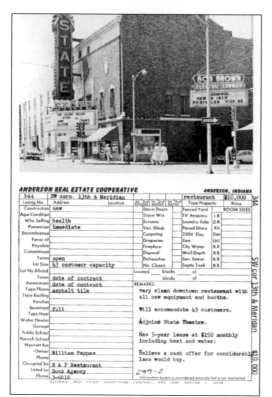

This Anderson real-estate document lists an asking price of $10,000 for the B&P Restaurant, located next to the State Theatre in downtown Anderson. (Courtesy of Perry Knox.)

ANDERSON REAL ESTATE COOPERATIVE — ANDERSON, INDIANA

344	SW corn. 13th & Meridian			restaurant	$10,000
Listing No.	Address	Location		Type Property	Price
Construction	new		Storm Doors	Fenced Yard	ROOM SIZES
Age-Condition			Storm Win.	TV Antenna	L.R.
Why Selling	health		Screens	Laundry Tubs	D.R.
Possession	immediate		Ven. Blinds	Paved Drive	Kit.
Encumbrance			Carpeting	220V. Elec.	Den
Favor of			Draperies	Gas	Util.
Payable			Fireplace	City Water	B.R.
Commitment			Disposal	Well Depth	B.R.
Terms	open		Dishwasher	San. Sewer	B.R.
Lot Size	43 customer capacity		No. Closets	Septic Tank	B.R.
Lot No.&Subd.			Located blocks of		
Taxes	date of contract		blocks of		
Assessment	date of contract		REMARKS.		
Type Floors	asphalt tile		very clean downtown restaurant with		
Type Roofing			all new equipment and booths.		
Porches					
Basement	full		Will accommodate 43 customers.		
Type Heat					
Water Heater			Adjoins State Theatre.		
Garage					
Public School			Has 5-year lease at $150 monthly		
Paroch.School			including heat and water.		
Nearest Bus					
Owner	William Pappas		Believe a cash offer for considerable		
Phone			less would buy.		
Occupied by	B & P Restaurant				
Listed by	Hook Agency		299-2		
Phone	3-6616				

Information herein is considered accurate but is not warranted.

NATIONAL REAL ESTATE ADVERTISING COMPANY, BOX 1038, DAYTON 1, OHIO

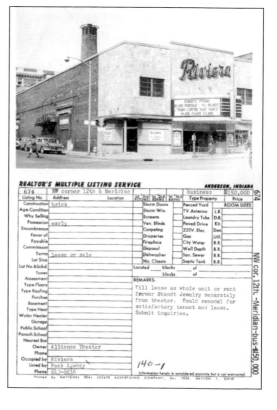

REALTOR'S MULTIPLE LISTING SERVICE — ANDERSON, INDIANA

674	NW corner 12th & Meridian			business	$150,000
Listing No.	Address	Location		Type Property	Price
Construction	brick		Storm Doors	Fenced Yard	ROOM SIZES
Age-Condition			Storm Win.	TV Antenna	L.R.
Why Selling			Screens	Laundry Tubs	D.R.
Possession	early		Ven. Blinds	Paved Drive	Kit.
Encumbrance			Carpeting	220V. Elec.	Den
Favor of			Draperies	Gas	Util.
Payable			Fireplace	City Water	B.R.
Commitment			Disposal	Well Depth	B.R.
Terms	lease or sale		Dishwasher	San. Sewer	B.R.
Lot Size			No. Closets	Septic Tank	B.R.
Lot No.&Subd.			Located blocks of		
Taxes			blocks of		
Assessment			REMARKS.		
Type Floors			Will lease as whole unit or rent		
Type Roofing			former Standt Jewelry separately		
Porches			from theater. Would remodel for		
Basement			satisfactory tenant and lease.		
Type Heat			Submit inquiries.		
Water Heater					
Garage					
Public School					
Paroch.School					
Nearest Bus					
Owner	Alliance Theater				
Phone					
Occupied by	Riviera		140-1		
Listed by	Hook Agency				
Phone	64-6616				

Information herein is considered accurate but is not warranted.

Printed by NATIONAL REAL ESTATE ADVERTISING COMPANY, Inc. 1038, DAYTON 1, OHIO

A price of $150,000 was placed on the Riviera Theatre when it went up for sale in 1960. The Riviera was on Meridian Street across from the Paramount Theatre. (Courtesy of Perry Knox.)

Casey's Dug-Out Drive-In, at 2713 Nichol Avenue, was valued at $23,000 when put on the market by owner Max H. Casey. The drive-in restaurant grossed $5,000 per month. (Courtesy of Perry Knox.)

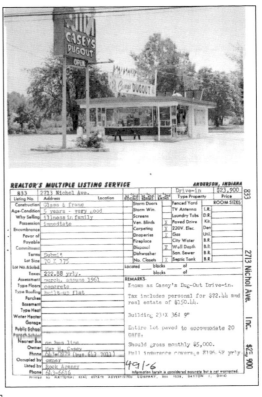

REALTOR'S MULTIPLE LISTING SERVICE — ANDERSON, INDIANA
Listing No. 833 — 2713 Nichol Ave. — Drive-in — $23,900

Frank's Fix-It Shop owner Frank Kanzler valued his business at $14,750, as listed on this for-sale document. The shop was located at 2432 Main Street, across from Mainview Apartments. (Courtesy of Perry Knox.)

ANDERSON REAL ESTATE COOPERATIVE — ANDERSON, INDIANA

DISCOVER THOUSANDS OF LOCAL HISTORY BOOKS FEATURING MILLIONS OF VINTAGE IMAGES

Arcadia Publishing, the leading local history publisher in the United States, is committed to making history accessible and meaningful through publishing books that celebrate and preserve the heritage of America's people and places.

Find more books like this at
www.arcadiapublishing.com

Search for your hometown history, your old stomping grounds, and even your favorite sports team.

Consistent with our mission to preserve history on a local level, this book was printed in South Carolina on American-made paper and manufactured entirely in the United States. Products carrying the accredited Forest Stewardship Council (FSC) label are printed on 100 percent FSC-certified paper.

MADE IN THE USA